Audubon's
MASTERPIECES

Audubon's
MASTERPIECES

JOHN JAMES AUDUBON
INTRODUCTION BY DAVID REINHARDT

JG
PRESS

Published 2009 by World Publications Group, Inc.
140 Laurel Street
East Bridgewater, MA 02333
www.wrldpub.net

Introduction copyright © 1996 W.S. Konecky Associates

ISBN 10: 1-57215-317-2
ISBN 13: 978-1-57215-317-2

Jacket Design: Louise Bebeau
Editor: Emily Zelner
Production Director: Ellen Milionis

Printed and bound in China by SNP Leefung Printers Limited

INTRODUCTION

JOHN JAMES AUDUBON devoted his life to his dream of identifying and depicting the birds of North America, and his work has had profound cultural and historical significance.

Born Jean Rapine in 1785 in the town of Les Cayes on the southern coast of Saint-Dominique, present day Haiti, the future artist was the illegitimate son of Captain Jean Audubon and Jeanne Rapine, a chambermaid who died a few months after the birth of her son.

At a young age Audubon was sent back to France and grew up around the town of Nantes, a coastal city in Brittany. He lived in the home of his father and his father's wealthy wife, Anne Moynet.

In 1803, at the age of 18, Audubon was sent to the United States by his father to avoid Napoleon's far-reaching conscription, learn English and look after the family property at Mill Grove near Philadelphia.

Early in his life Audubon learned to use his artistic talents to barter for the necessities of life. In 1805 he gave drawing lessons in exchange for being tutored in English. It is clear that he learned the rudiments of his drawing style in France. It is uncertain but seems likely that as a boy Audubon worked briefly with a student or an admirer of the master—Jacques-Louis David; perhaps at the Free Academy of Drawing in Nantes.

From a very young age Audubon thought of himself not only as an artist but also as an ornithologist. This helps explain the great precision displayed in his renderings. In particular, Audubon showed a special interest in the feeding habits of birds and many of his works depict this fascination.

In 1812 Audubon became a U.S. citizen but even before that he was in love not only with the young nation's wildlife but with its character as well. There existed a perfect match between the wild new country and the exuberance and independent spirit of the artist. During the first two decades of the nineteenth century, when American landscape painters were busy painting prospects of cultivated land and views of the country seats of the wealthy, before the Hudson River School existed, Audubon plunged into the wilderness to paint the beauty and richness of America through its birds.

He explored the young nation in its entirety, traveling north, south east and west, as no American artist had before him. He would awake, as he said, "on the alder-fringed

brook of some northern valley, or in the midst of some yet unexplored forest of the west, or perhaps on the soft and warm sands of the Florida shores, listening to the pleasing melodies of songsters innumerable."

In late summer of 1807 Audubon moved to and opened a store in the then burgeoning trading town of Louisville, Kentucky. In April 1808, he brought his bride, Lucy Bakewell, to Louisville and in 1810 they moved down river to Henderson, Kentucky, a village of no more than two hundred. It was in Henderson that the Audubons raised their two sons, Victor Gifford and John Woodhouse Audubon. Audubon remained in Kentucky for twelve years, longer than he stayed anywhere else, and would ever after consider himself a Kentuckian.

During the years 1813 to 1820 Audubon was less active than usual in his artwork. He purchased property in Henderson, then with several partners built a timber mill in 1816. The Audubons' two-year-old daughter, Lucy, died in 1817. Captain Audubon, the artist's father, died in Nantes the following year. Finally, the financial panic of 1819 proved devastating; Audubon's fortunes hit their nadir with the collapse of his enterprises and his personal bankruptcy.

Retrospectively, Audubon was inclined to blame himself for his failure, recalling: "For a period of twenty years, my life was a succession of vicissitudes. I tried various branches of commerce, but they all proved unprofitable, doubtless because my whole mind was ever filled with my passion for rambling and admiring those objects of nature from which alone I received the purest gratification."

Completely without funds, with a wife and two young sons, Audubon turned back to his artistic talents to support himself. In the fall of 1819 he began to paint portraits as a means of income. It was at this point in Audubon's life , when he was completely living by his wits, that he began to have his first success as an artist. In addition to his portrait business, he began working for the new Western Museum in Cincinnati as a habitat painter. Between this job and making portraits at twenty-five dollars apiece, he was able to establish a drawing school.

In 1820, Audubon seemed to be settling down, but he was about to embark on a project that would change his life forever. He would leave both his beloved Kentucky and his unlamented mercantile career behind in order to find and draw all the birds of North America.

Audubon spent the next six years traveling from the Atlantic to the Mississippi, from New England to Florida, to realize the dream he had nurtured since 1806. His interest in birds, which in the beginning had been a leisure-time avocation, now became his obsession and the guiding force of his existence.

In June of 1826 Audubon sailed for Europe in search of an engraver and the patronage he so desperately needed to complete his ambitious project. He remained in Great Britain from 1826 to late spring of 1829. This period proved to be crucially important for the artist. He won widespread artistic and scientific acclaim for his drawings, found the London firm of Havell & Sons to engrave them, published several learned papers, gained election to a number of prominent learned societies, and not least, found enough subscribers to make it possible to proceed with publication.

The success that Audubon had craved in Philadelphia and New York had been won in

Liverpool, Edinburgh and London. The artist had been raised and trained in France, and had adopted America as his native land but, as he said, "to Britain I owe nearly all my success."

Audubon returned to the United States in May 1829 and frantically searched for both American subscribers to his project and additional American birds. On April 1, 1830 he sailed again for London in order to personally oversee Havell's printing of the plates and to begin work on the five-volume Ornithological Biography. By late 1838, after two more transatlantic crossings, all of the drawings had been engraved.

Audubon's pioneering achievement set the standard for ornithological painting. In comparison the work of his contemporaries seems lifeless. In a radical departure from the prevailing practice of his day he painted birds within their natural habitats. It is clear that he had a dual purpose in his drawings, aiming on one hand to give accurate, scientific portraits of each species, and on the other to make works of art that were inventive, varied and beautiful.

Although Audubon's work was prolific, he never became wealthy. He was, however, finally able to live comfortably. In 1841 he bought a thirty-five acre tract of land on the Hudson, which he called Minnie's Land, in what is today the Washington Heights section of Manhattan.

In the late 1840s Audubon hit upon the idea of bringing out a smaller, Octavo, edition of the Birds of America. He explains his reasons for so doing in the preface: "Having been frequently asked, for several years past, by numerous friends of science, both in America and Europe, to present to them and to the public a work on the Ornithology of our country, similar to my large work, but of such dimensions, and at such a price, as would enable every student or lover of nature to place it in his library, and look upon it during his leisure hours as a pleasing companion—I have undertaken this task with the hope that these good friends and the public will receive the "BIRDS IN AMERICA" in their present miniature form, with that favour and kindness they have already evinced toward one who can never cease to admire and study with zeal and the most heartfelt reverence, the wonderful productions of an almighty creator."

Audubon added thirty-five additional plates for the Octavo edition. It was his last great achievement. He died in 1851, at the age of 66. The 150 plates that follow have been selected from this Octavo edition. They have been reproduced from the first edition of the work which was published in 10 volumes over the course of seven years starting in 1841. It is the editor's hope that they convey the depth and range of Audubon's incomparable artistry.

Audubon succeeded in ways that surpassed his greatest ambitions. He had hoped to draw the birds of America in an artistic and scientific fashion, and this project was wholly realized. But he accomplished much more. His name has become synonymous with love of birds and with preservation of the environment, in ways that would have astonished and pleased him. Today he is recognized as one of the most gifted and original artists of his time in America.

LIST OF PLATES

❦ ❦

NAME OF SPECIES ON OCTAVO PLATE

PLATE 1 • Californian Turkey Vulture
PLATE 4 • Caracara Eagle
PLATE 12 • Golden Eagle
PLATE 13 • Washington Sea Eagle
PLATE 15 • Common Osprey Fish Hawk
PLATE 18 • Swallow-tailed Hawk
PLATE 19 • Iceland or Gyr Falcon
PLATE 22 • Sparrow Hawk
PLATE 23 • Gos Hawk
PLATE 28 • Snowy Owl
PLATE 34 • Barn Owl
PLATE 35 • Great Cinereous Owl
PLATE 36 • Barred Owl
PLATE 39 • Great Horned-Owl
PLATE 44 • American Swift
PLATE 45 • Purple Martin
PLATE 47 • Cliff Swallow
PLATE 48 • Barn or Chimney Swallow
PLATE 49 • Violet-green Swallow
PLATE 50 • Bank Swallow
PLATE 52 • Fork-tailed Flycatcher
PLATE 56 • Tyrant Flycatcher or Kingbird
PLATE 63 • Pewee Flycatcher
PLATE 68 • American Redstart
PLATE 76 • Yellow-crowned Wood Warbler
PLATE 77 • Audubon's Wood Warbler
PLATE 79 • Yellow-throated Wood Warbler
PLATE 86 • Caerulean Wood Warbler
PLATE 91 • Blue Yellow-backed Wood Warbler
PLATE 95 • Black-throated Blue Wood Warbler
PLATE 97 • Prairie Wood Warbler
PLATE 99 • Connecticut Warbler
PLATE 100 • MacGillivray's Ground Warbler
PLATE 101 • Mourning Ground Warbler
PLATE 104 • Swainson's Swamp Warbler
PLATE 105 • Worm-Eating Swamp Warbler
PLATE 107 • Golden-winged Swamp Warbler
PLATE 108 • Bachman's Swamp Warbler
PLATE 109 • Carbonated Swamp Warbler
PLATE 111 • Blue-winged Yellow Swamp Warbler
PLATE 120 • House Wren
PLATE 121 • Winter Wren
PLATE 123 • Marsh Wren
PLATE 125 • Crested Titmouse
PLATE 127 • Carolina Titmouse
PLATE 130 • Chestnut-crowned Titmouse

Plate 132 • American Golden-crested Kinglet
Plate 134 • Common Blue Bird
Plate 136 • Arctic Blue Bird
Plate 138 • Common Mocking Bird
Plate 141 • Ferruginous Mocking Bird
Plate 142 • American Robin or Migratory Thrush
Plate 148 • Golden-Crowned Wagtail Thrush
Plate 154 • Chestnut-collared Lark Bunting
Plate 155 • Snow Lark Bunting
Plate 167 • Common Snow Bird
Plate 169 • Painted Bunting
Plate 174 • Sharp-tailed Finch
Plate 177 • Lincoln's Pinewood Finch
Plate 184 • Yarrell's Goldfinch
Plate 191 • White-throated Finch
Plate 192 • White-crowned Finch
Plate 195 • Towhe Ground Finch
Plate 196 • Crested Purple Finch
Plate 201 • White-winged Crossbill
Plate 203 • Common Cardinal Grosbeak
Plate 205 • Rose-breasted Song Grosbeak
Plate 208 • Summer Red-Bird
Plate 214 • Red-and-white-shouldered Marsh Blackbird
Plate 215 • Red-and-black-shouldered Marsh Blackbird
Plate 216 • Red-winged Starling
Plate 217 • Baltimore Oriole or Hang Nest
Plate 220 • Boat-tailed Grackle
Plate 221 • Common or Purple Crow Blackbird
Plate 224 • Raven
Plate 225 • Common American Crow
Plate 227 • Common Magpie
Plate 229 • Columbia Magpie or Jay
Plate 231 • Blue Jay
Plate 233 • Florida Jay
Plate 235 • Clarke's Nutcracker
Plate 243 • Red-eyed Vireo or Greenlet
Plate 248 • Red-bellied Nuthatch
Plate 251 • Mango Humming Bird
Plate 252 • Anna Humming Bird
Plate 253 • Ruby-throated Humming Bird
Plate 255 • Belted Kingfisher
Plate 257 • Pileated Woodpecker
Plate 268 • Arctic Three-toed Woodpecker
Plate 270 • Red-bellied Woodpecker
Plate 271 • Red-headed Woodpecker
Plate 273 • Golden-winged Woodpecker
Plate 278 • Carolina Parrot or Parrakeet
Plate 279 • Band-tailed Dove or Pigeon
Plate 280 • White-headed Dove or Pigeon
Plate 286 • Carolina Turtle Dove
Plate 287 • Wild Turkey
Plate 288 • Wild Turkey
Plate 291 • Plumed Patridge

10

PLATE 301 • Rock Ptarmigan
PLATE 303 • Purple Gallinule
PLATE 304 • Common Gallinule
PLATE 310 • Clapper Rail or Salt Water Marsh Hen
PLATE 313 • Whooping Crane
PLATE 314 • Whooping Crane (Sandhill Crane)
PLATE 321 • Piping Plover
PLATE 323 • Turnstone
PLATE 333 • Curlew Sandpiper
PLATE 344 • Yellow Shank's Snipe
PLATE 346 • Greenshank
PLATE 350 • Wilson's Snipe—Common Snipe
PLATE 354 • Black-necked Stilt
PLATE 355 • Long-billed Curlew
PLATE 358 • Glossy Ibis
PLATE 359 • Scarlet Ibis
PLATE 360 • White Ibis
PLATE 361 • Wood Ibis
PLATE 362 • Roseate Spoonbill
PLATE 363 • Black-Crowned Heron or Qua Bird
PLATE 364 • Yellow Crowned Night Heron
PLATE 367 • Green Heron
PLATE 368 • Great White Heron
PLATE 369 • Great Blue Heron
PLATE 370 • Great American White Egret
PLATE 371 • Reddish Egret
PLATE 372 • Blue Heron
PLATE 373 • Louisiana Heron
PLATE 374 • Snowy Heron
PLATE 375 • American Flamingo
PLATE 381 • Snow Goose
PLATE 391 • Wood Duck—Summer Duck
PLATE 392 • American Green-winged Teal
PLATE 394 • Shoveller Duck
PLATE 395 • Canvass Back Duck
PLATE 396 • Red-headed Duck
PLATE 399 • Ruddy Duck
PLATE 406 • Golden Eye Duck
PLATE 407 • Western Duck
PLATE 411 • Buff-breasted Merganser Goosander
PLATE 414 • White Merganser, Smew, White Nun
PLATE 415 • Common Cormorant
PLATE 416 • Double-crested Cormorant
PLATE 419 • Violet-green Cormorant
PLATE 420 • American Anhinga Snake Bird
PLATE 422 • American White Pelican
PLATE 423 • Brown Pelican
PLATE 425 • Common Gannet
PLATE 427 • Tropic Bird
PLATE 431 • Sandwich Tern
PLATE 436 • Arctic Tern
PLATE 448 • Herring or Silvery Gull
PLATE 454 • Dusky Albatross

11

PLATE 460 • Wilson's Petrel—Mother Carey's chicken
PLATE 464 • Common or Arctic Puffin
PLATE 465 • Great Auk
PLATE 473 • Foolish Guillemot—Murre
PLATE 474 • Black Guillemot
PLATE 476 • Great Northern Diver Loon
PLATE 478 • Red-throated Diver
PLATE 479 • Crested Grebe
PLATE 481 • Horned Grebe
PLATE 490 • Yellow-bellied Flycatcher
PLATE 494 • Missouri Red-moustached Woodpecker
PLATE 497 • Western Shore Lark
PLATE 498 • Common Scaup Duck
PLATE 499 • Common Troupial

12

PLATES

Pl. 1. Californian Turkey Vulture

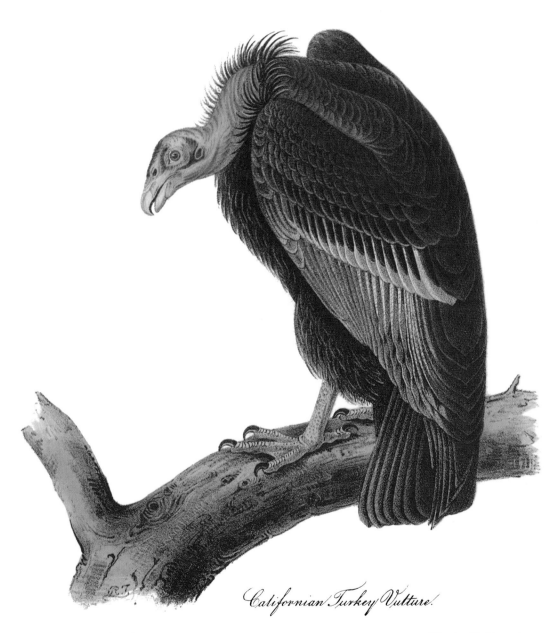

Californian Turkey Vulture.

Drawn from Nature by J.J.Audubon.F.R.S.F.L.S. Lithᵈ Printed & Colᵈ by J.T.Bowen.Philadᵃ

Pl. 4. Caracara Eagle

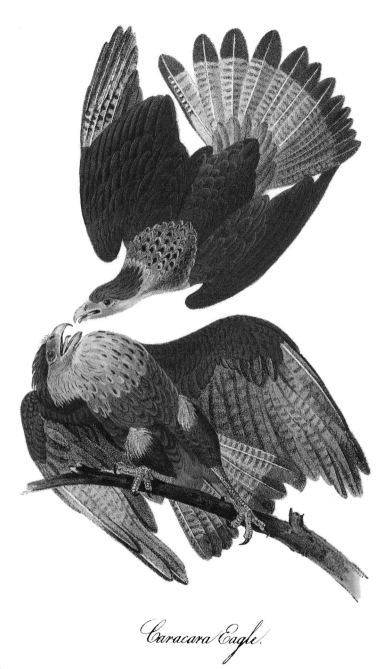

Caracara Eagle.

Drawn from Nature by J.J.Audubon, F.R.S.F.L.S.

Lith.d Printed & Col.d by J.T Bowen.Philad.a

Pl. 12. Golden Eagle

Pl. 12.

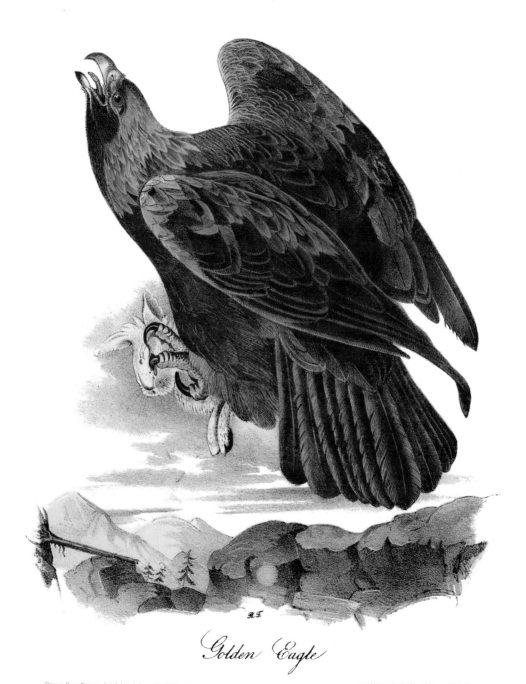

Golden Eagle

Drawn from Nature by J.J.Audubon F.R.S.F.L.S. Lithd Printed & Cold by J.T.Bowen,Philada

Pl. 13. Washington Sea Eagle

Pl. 13.

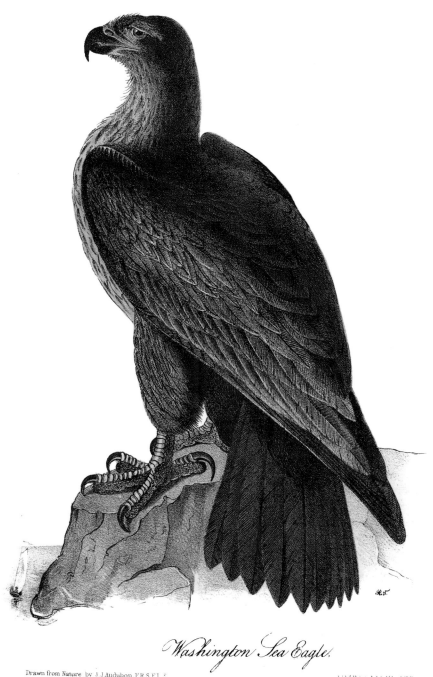

Washington Sea Eagle.

Drawn from Nature by J.J.Audubon.F.R.S.F.L.S. Lith⁴ Printed & Col⁴ by J.T.Bowen.Philad⁴.

Pl. 15. Common Osprey Fish Hawk

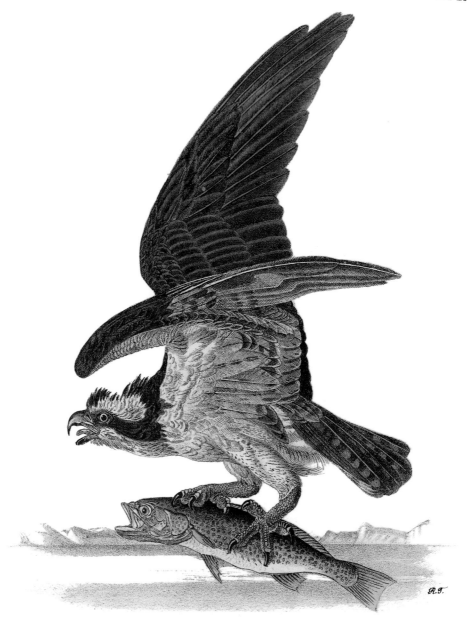

Common Osprey. Fish Hawk.

Drawn from Nature by J.J.Audubon, F.R.S.F.L.S.

Lith⁴ Printed & Col⁴ by J.T. Bowen Philad⁴

Pl. 18. Swallow-tailed Hawk

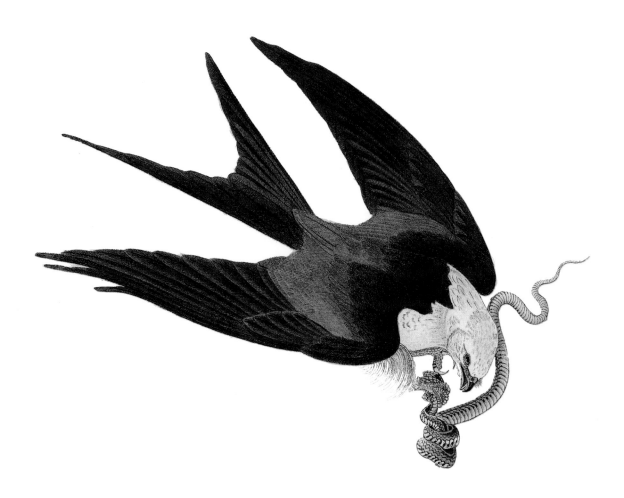

Swallow-tailed Hawk.

Drawn from Nature by J.J.Audubon, F.R.S.F.L.S. Lithd Printed & Cold by J.T. bowen, Philada

Pl. 19. Iceland or Gyr Falcon

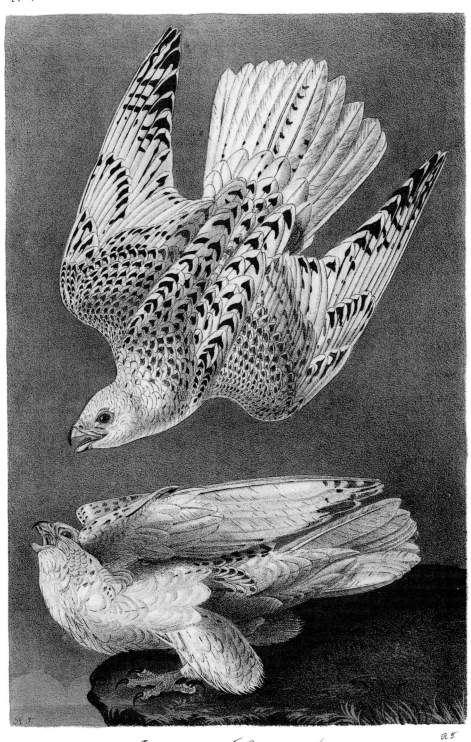

Iceland or Gyr Falcon.

Drawn from Nature by J.J.Audubon, F.R.S.F.L.S.

Lith⁴ Printed & Col⁴ by J.T.Bowen, Philad⁴

Pl. 22. Sparrow Hawk

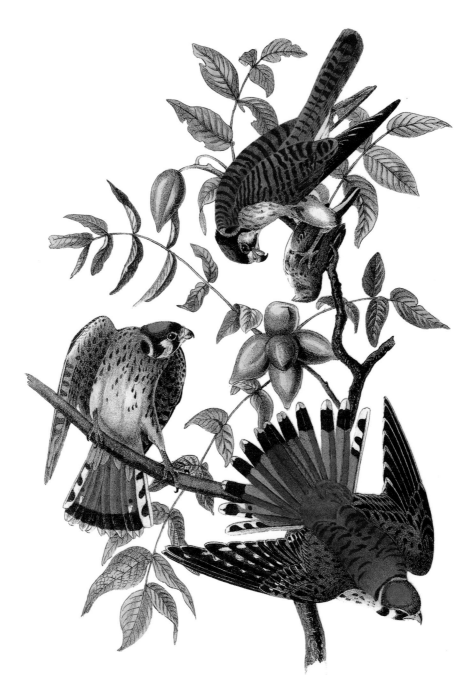

Sparrow Hawk.

Drawn from Nature by J.J.Audubon.F.R.S.F.L.S.

Lithd. Printed & Cold by J.T. Bowen. Philada.

Pl. 23. Gos Hawk

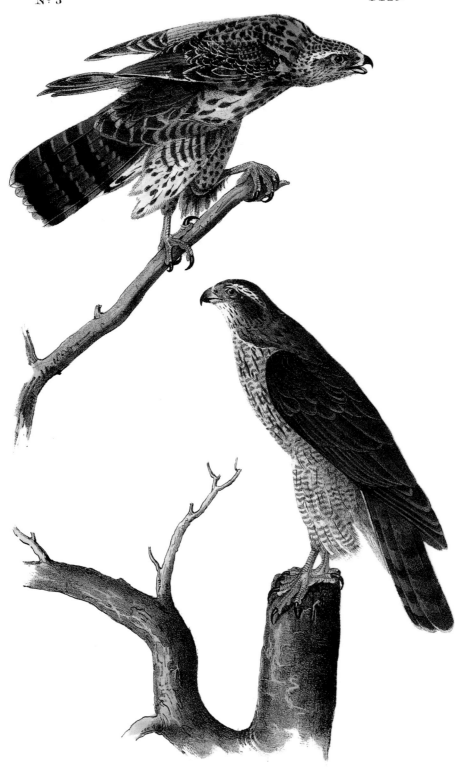

Goshawk.

Drawn from Nature by J.J.Audubon, F.R.S.F.L.S. Lith⁴ Printed & Col⁴ by J.T. Bowen, Philad⁴

Pl. 28. Snowy Owl

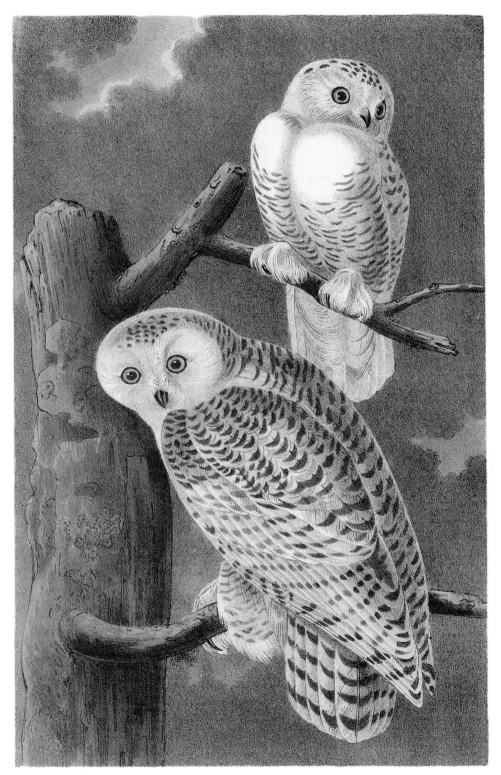

Snowy Owl.

Drawn from Nature by J.J.Audubon,F.R.S.F.L.S. Lithd. Printed & Cold. by J.T.Bowen, Philada

Pl. 34. Barn Owl

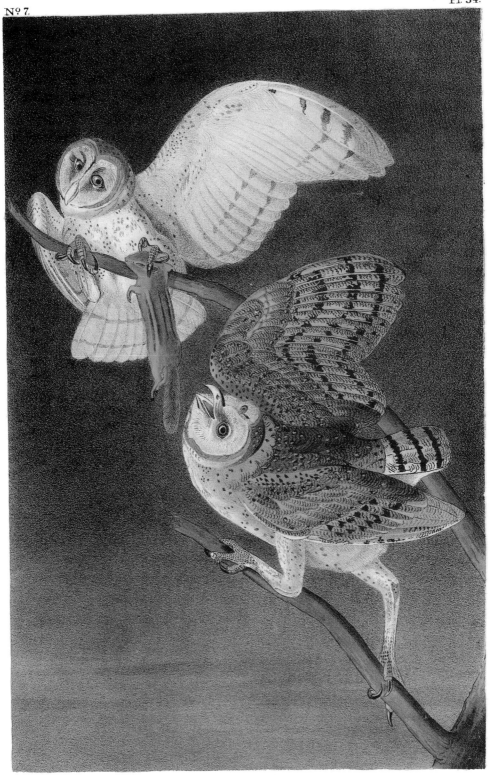

R.T.

Barn Owl.

Drawn from Nature by J.J.Audubon.F.R.S.F.L.S.

Lith.ᵈ Printed & Col.ᵈ by J.T.Bowen,Philad.ᵃ

Pl. 35. Great Cinereous Owl

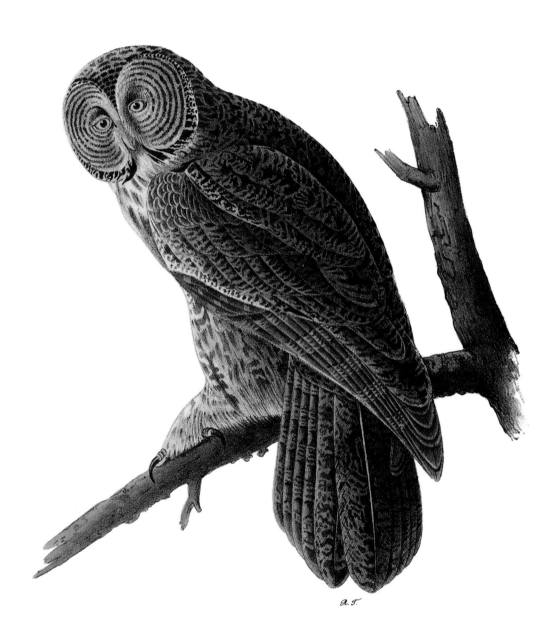

Great Cinereous Owl.

Drawn from Nature by J.J.Audubon, F.R.S.F.L.S.

Lith⁴ Printed & Col⁴ by J.T.Bowen, Philad⁴

Pl. 36. Barred Owl

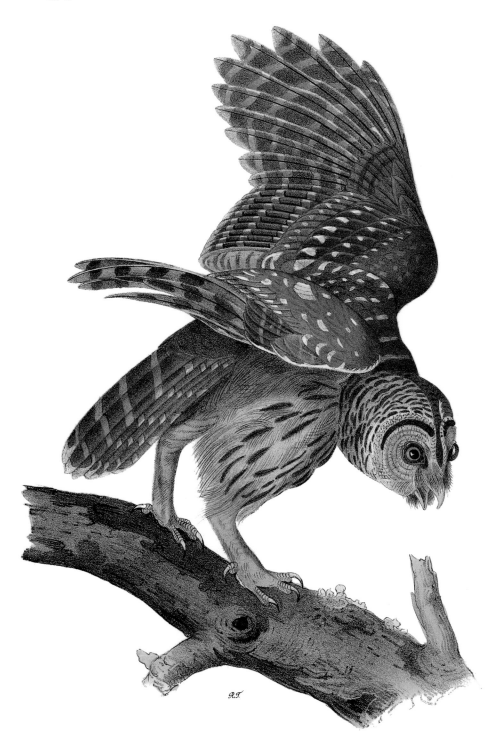

Barred Owl.

Drawn from Nature by J.J.Audubon,F.R.S.F.L.S.

Lith Printed & Col by J.T Bowen Philad

Pl. 39. Great Horned-Owl

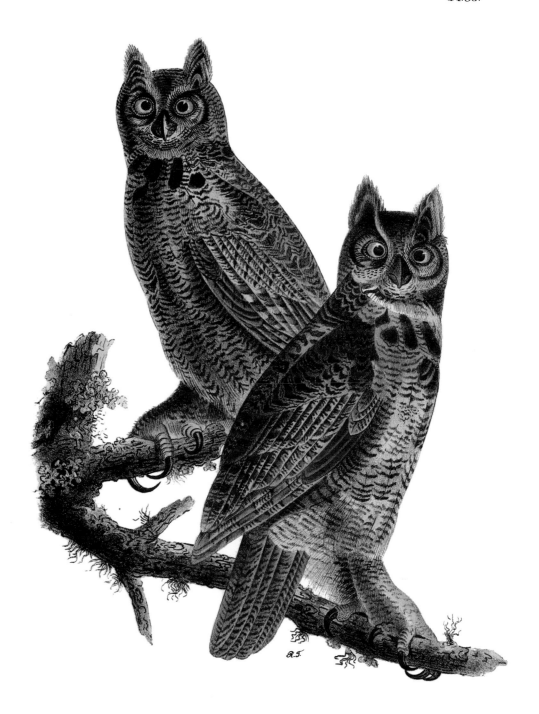

Great Horned-Owl.

Drawn from Nature by J.J.Audubon.F.R.S.F.L.S.

Lith.ᵈ Printed & Col.ᵈ by J.T.Bowen,Philad.ᵃ

Pl. 44. American Swift

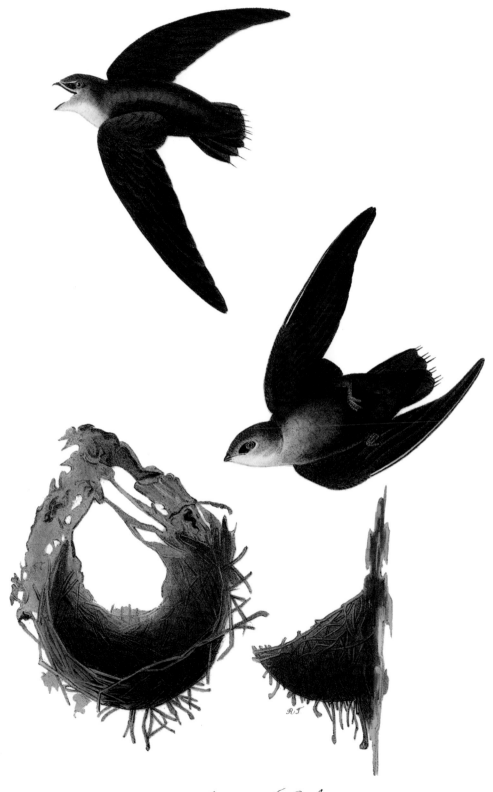

American Swift.
(Nests)

Drawn from Nature by J.J.Audubon. F.R.S.F.L.S.

Lith⁴ Printed & Col⁴ by J.T. Bowen. Philad⁴.

Pl. 45. Purple Martin

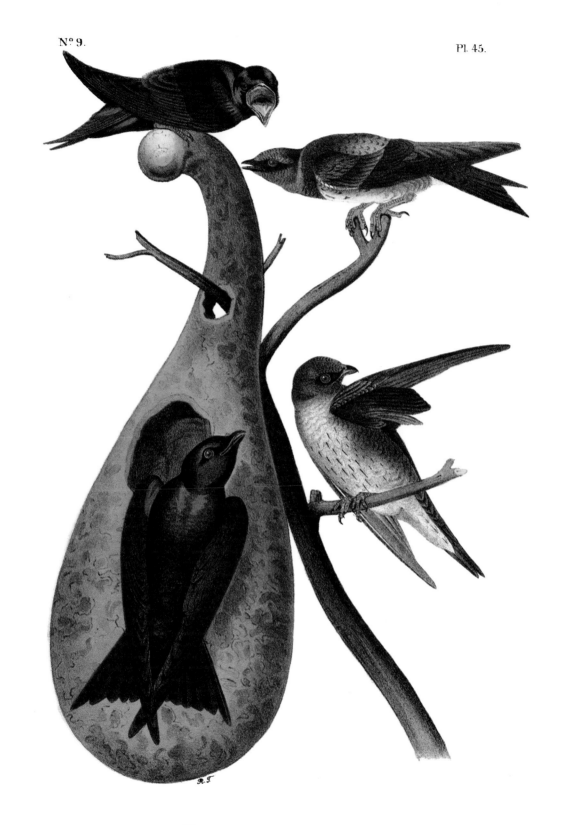

Purple Martin.
(Calabash.)

Drawn from Nature by J.J.Audubon.F.R.S.F.L.S.

Lithd Printed & Cold by J.T. Bowen Philada

Pl. 47. Cliff Swallow

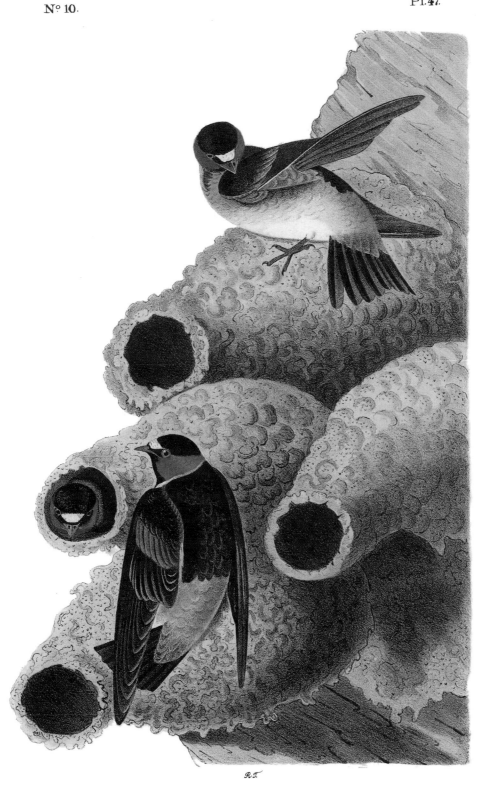

R.T.

Cliff Swallow.
(*Nests.*)

Drawn from Nature by J.J.Audubon, F.R.S.F.L.S.

Lithd. Printed & Cold. by J.T. Bowen, Philada.

Pl. 48. Barn or Chimney Swallow

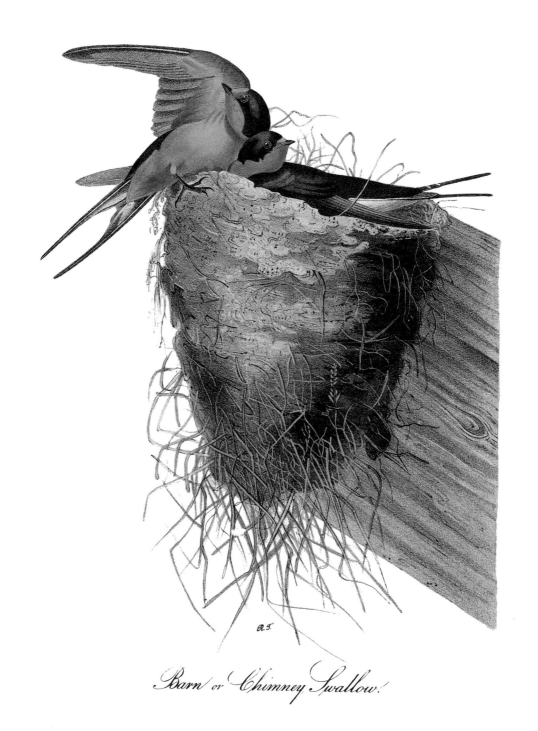

Barn or Chimney Swallow.

Drawn from Nature by J.J.Audubon, F.R.S.F.L.S.

Lithd. Printed & Cold. by J.T. Bowen, Philada.

Pl. 49. Violet-green Swallow

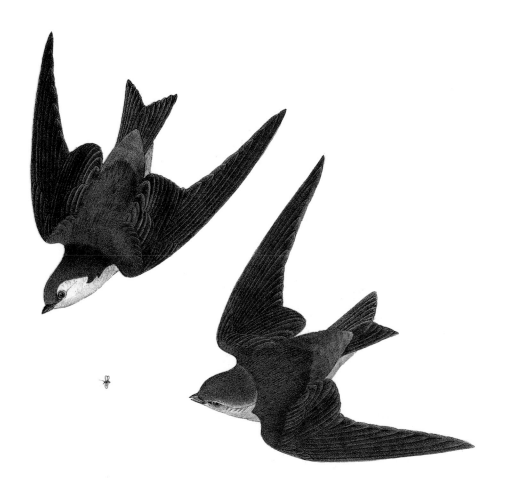

R.S.

Violet-Green Swallow.

Drawn from Nature by J.J.Audubon.F.R.S.F.L.S.

Lithd Printed & Cold by J.T.Bowen.Philadª

Pl. 50. Bank Swallow

Pl. 50.

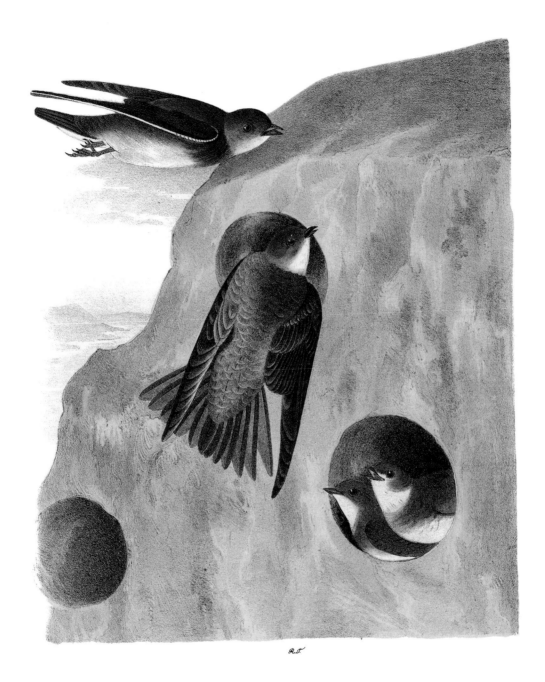

R.T.

Bank Swallow.

Drawn from Nature by J.J.Audubon, F.R.S.F.L.S.

Lith.ᵈ Printed & Col.ᵈ by J.T.Bowen, Philad.ᵃ

Pl. 52. Fork-tailed Flycatcher

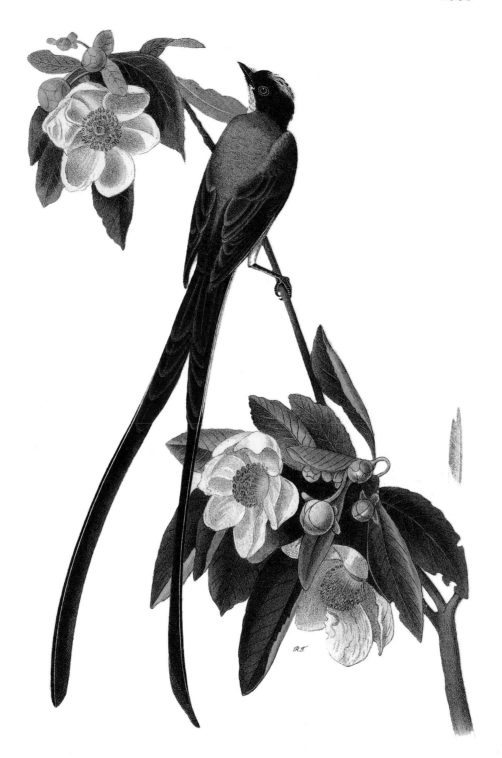

Fork-tailed Flycatcher.

Gordonia Lasianthus.

Drawn from Nature by J.J.Audubon.F.R.S.F.L.S.

Lithᵈ Printed & Colᵈ by J.T.Bowen.Philadᵃ

Pl. 56. Tyrant Flycatcher or Kingbird

Pl. 56.

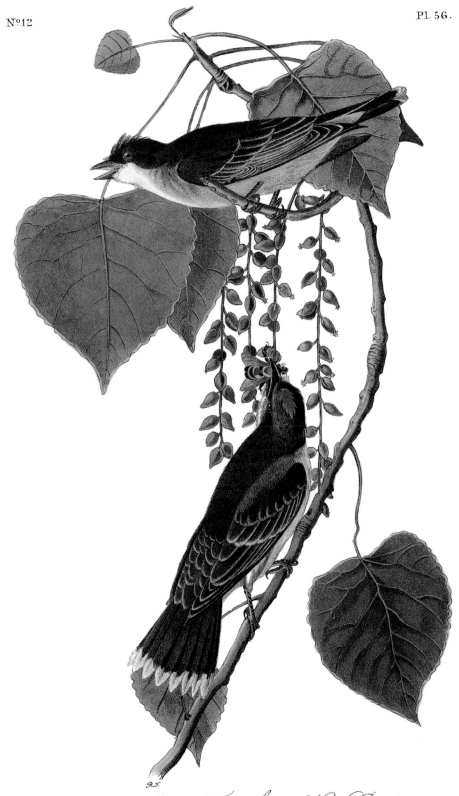

Tyrant Flycatcher or King Bird.
Cotton-wood. Populus candicans.

Drawn from Nature by J.J.Audubon, F.R.S.F.L.S. Lithd. Printed & Cold. by J.T. Bowen, Philad.a

Pl. 63. Pewee Flycatcher

Pl.63.

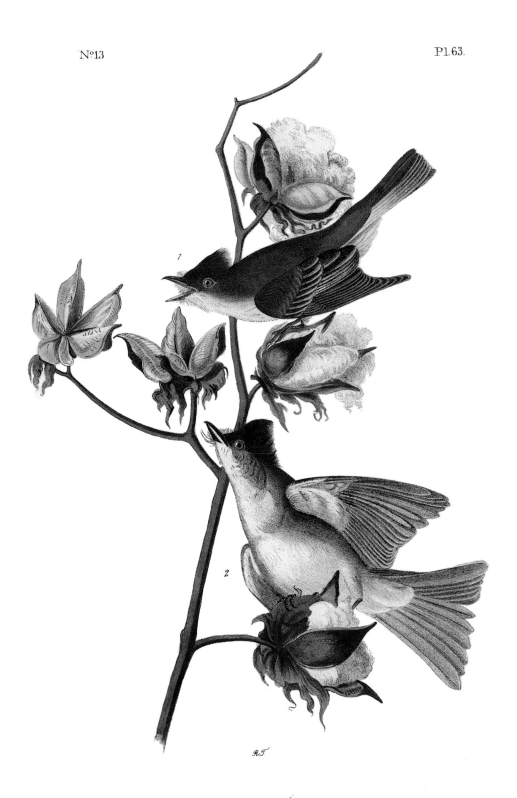

Pewee Flycatcher.

Cotton Plant. Gossypium Herbaceum.

1 Male 2 Female

Drawn from Nature by J.J.Audubon.F.R:S.F.L.S. Lithd Printed & Cold by J.T.Bowen. Philad

Pl. 68. American Redstart

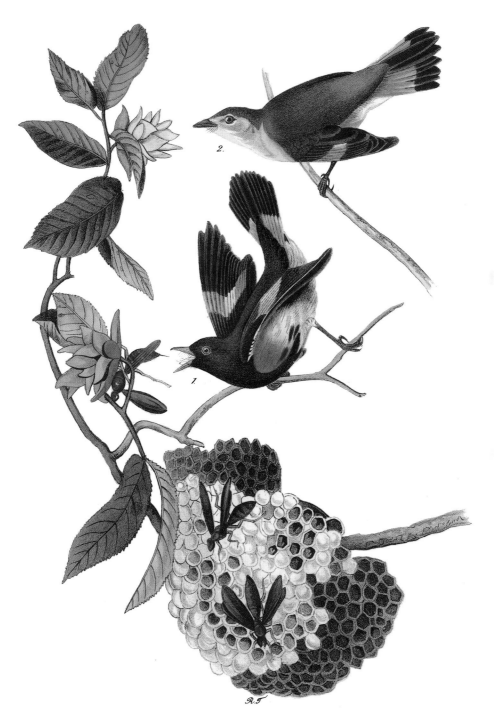

American Redstart
Virginian Hornbeam or Iron wood Tree.

1. Male 2. Female

Drawn from Nature by J. J. Audubon, F.R.S.F.L.S. Lithd Printed & Cold by J.T. Bowen, Philadª

Pl. 76. Yellow-crowned Wood Warbler

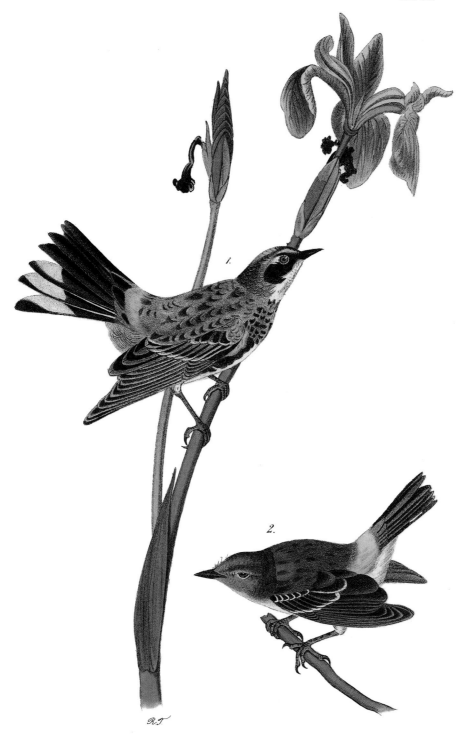

Yellow-crowned Wood-Warbler.

Iris versicolor.

1. Male. 2. Young.

Drawn from Nature by J.J.Audubon, F.R.S.F.L.S. Lithd. Printed & Cold. by J.T.Bowen, Philada.

Pl. 77. Audubon's Wood Warbler

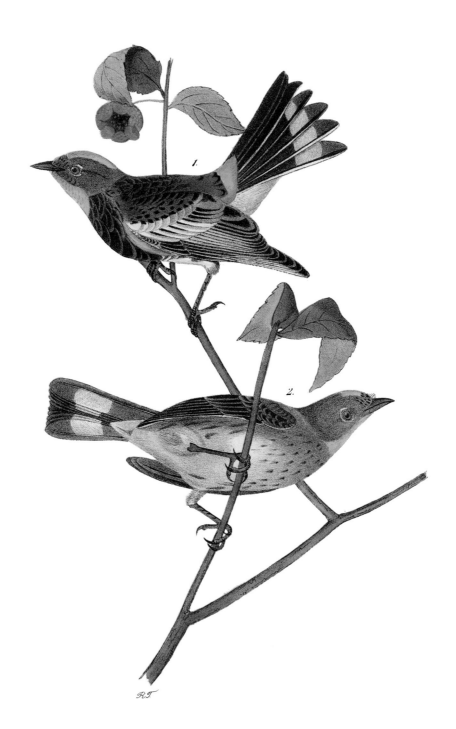

Audubon's Wood-Warbler.
Strawberry Tree. Euonymus Americanus.

1. Male 2 Female

Drawn from Nature by J.J.Audubon.F.R.S.F.L.S.

Lith⁴ Printed & Col⁴ by J.T.Bowen,Philad⁴

Pl. 79. Yellow-throated Wood Warbler

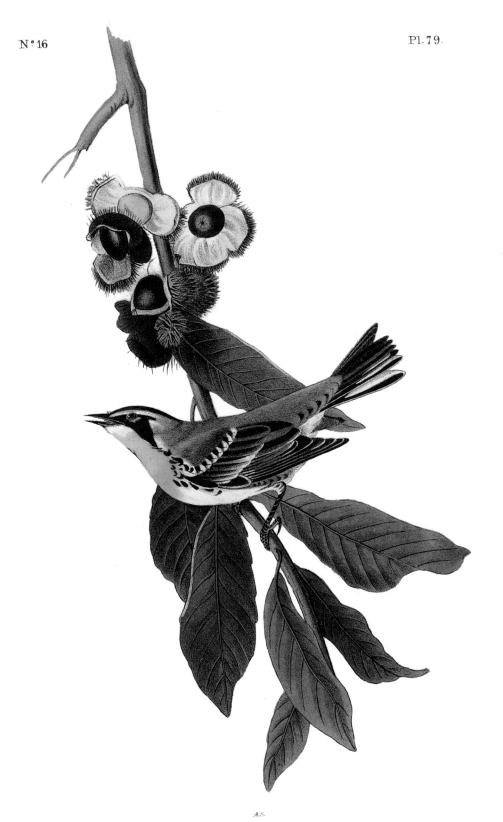

Yellow-throated Wood-Warbler.
Chinquapin Castanea pumila.

Male.

Drawn from Nature by J.J.Audubon, F.R.S.F.L.S. Lith⁴ Printed & Col⁴ by J.T.Bowen,Philad⁴

Pl. 86. Caerulean Wood Warbler

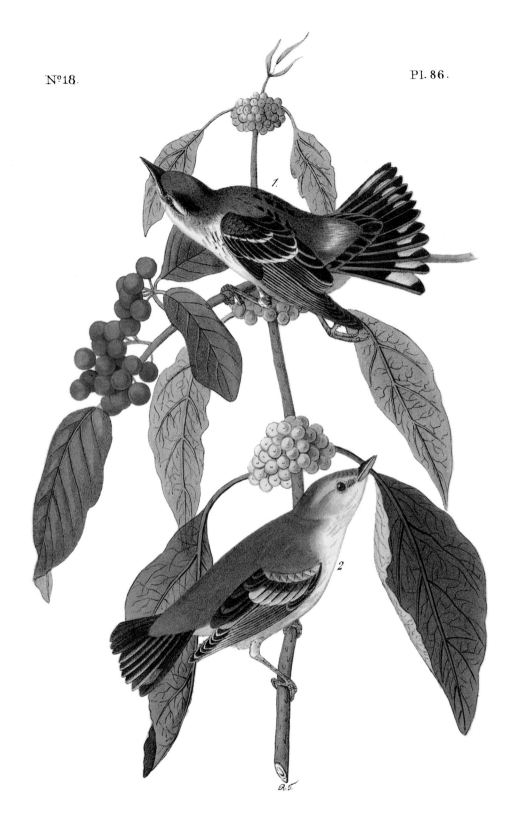

Cærulean Wood-Warbler.

1. Old Male. 2. Young Male.
Bear-berry and Spanish Mulberry.

Drawn from Nature by J.J.Audubon, F.R.S. F.L.S.

Lithᵈ Printed & Colᵈ by J.T.Bowen, Philadᵃ

Pl. 91. Blue Yellow-backed Wood Warbler

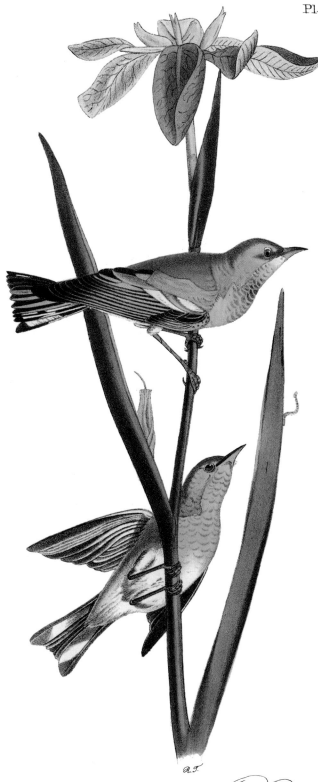

Blue yellow-backed Wood Warbler.

1. Male. 2. Female.
Louisiana Flag.

Drawn from Nature by J.J.Audubon.F.R.S.F.L.S. Lith.ª Printed & Col.ª by J.T.Bowen.Phila.ª

Pl. 95. Black-throated Blue Wood Warbler

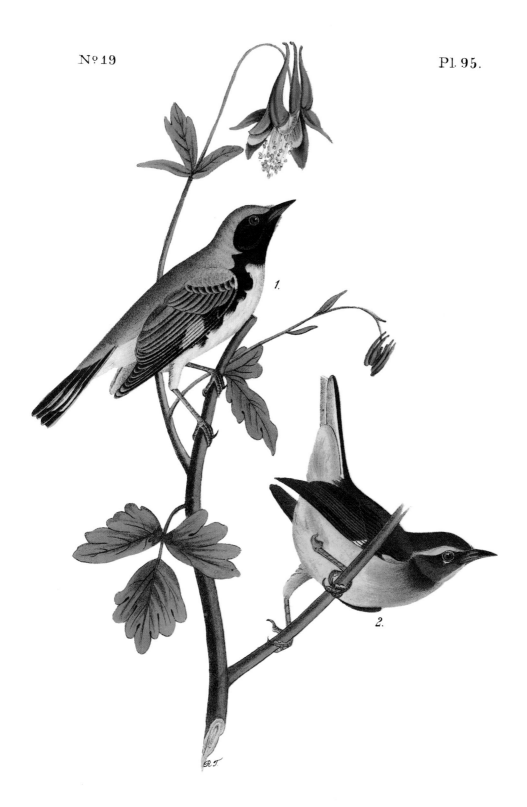

Black-throated Blue Wood-Warbler.

1. Male 2. Female.

Canadian Columbine.

Drawn from Nature by J.J.Audubon, F.R.S.F.L. Lith⁴ Printed & Col⁴ by J.T Bowen. Philad⁴

Pl. 97. Prairie Wood Warbler

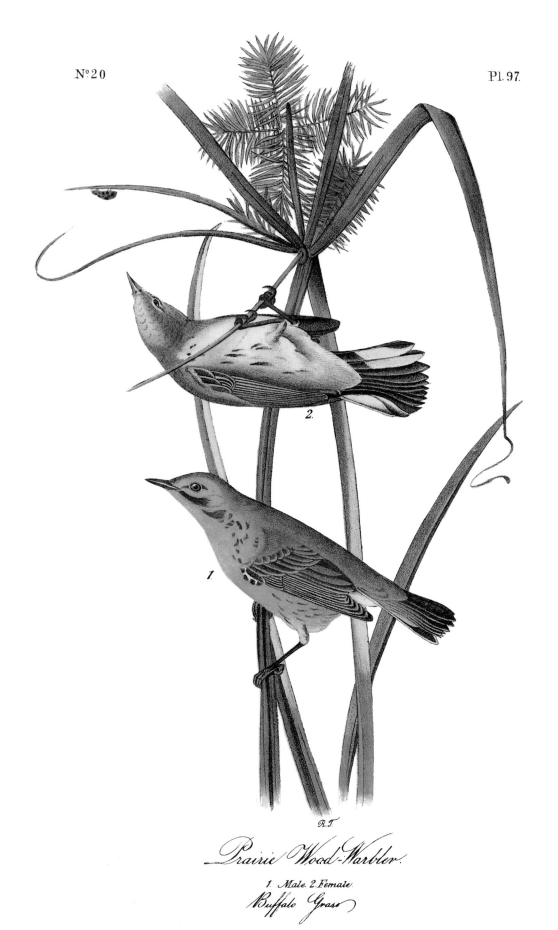

R.T.

Prairie Wood-Warbler.

1. Male. 2. Female.
Buffalo Grass

Drawn from Nature by J.J.Audubon, F.R.S.F.L.S. Lithd Printed & Cold by J.T.Bowen, Philad.

Pl. 99. Connecticut Warbler

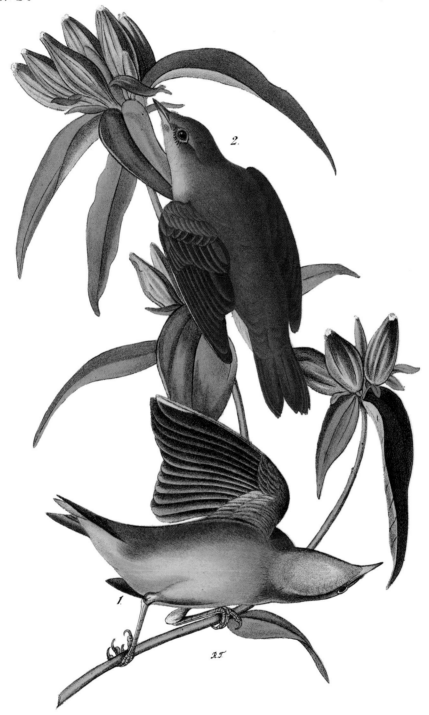

Connecticut Warbler.

1. Male. 2. Female.
Gentiana Saponaria.

Drawn from Nature by J.J.Audubon F.R.S. F.L.S. Lith⁴ Printed & Col⁴ by J.T.Bowen, Philad.

Pl. 100. MacGillivray's Ground Warbler

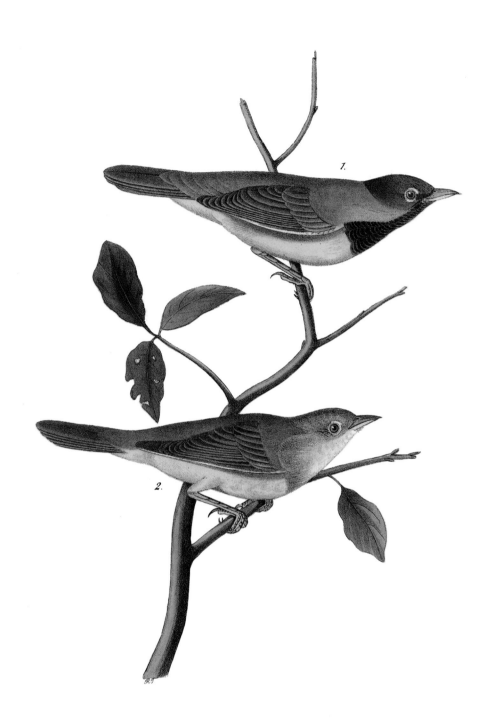

Macgillivray's Ground-Warbler

1. Male. 2. Female

Drawn from Nature by J.J.Audubon.F.R.S.F.L.S. Lith.ᵈ Printed & Col.ᵈ by J.T.Bowen.Philad.ᵃ

Pl. 101. Mourning Ground Warbler

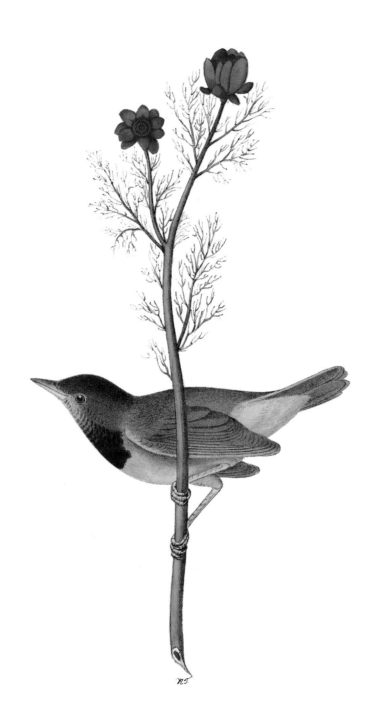

Mourning Ground-Warbler.

Male.

Pheasant's-eye Flos-Adonis.

Drawn from Nature by J.J.Audubon,F.R.S.F.L.S. Lithd Printed & Cold by J.T.Bowen,Philada

Pl. 104. Swainson's Swamp Warbler

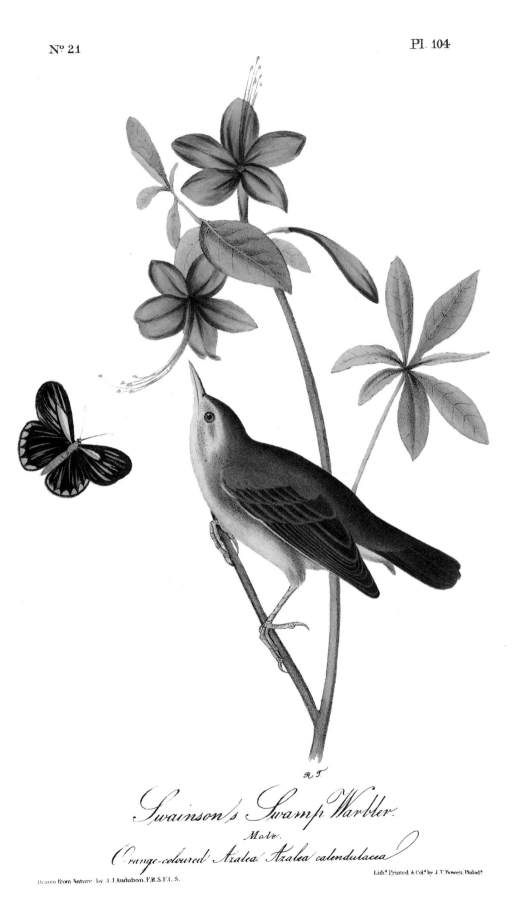

Swainson's Swamp Warbler.

Male.

Orange-coloured Azalea. Azalea calendulacea

Drawn from Nature by J.J. Audubon, F.R.S.F.L.S.

Lithd Printed & Cold by J.T. Bowen, Philad^a

Pl. 105. Worm-eating Swamp Warbler

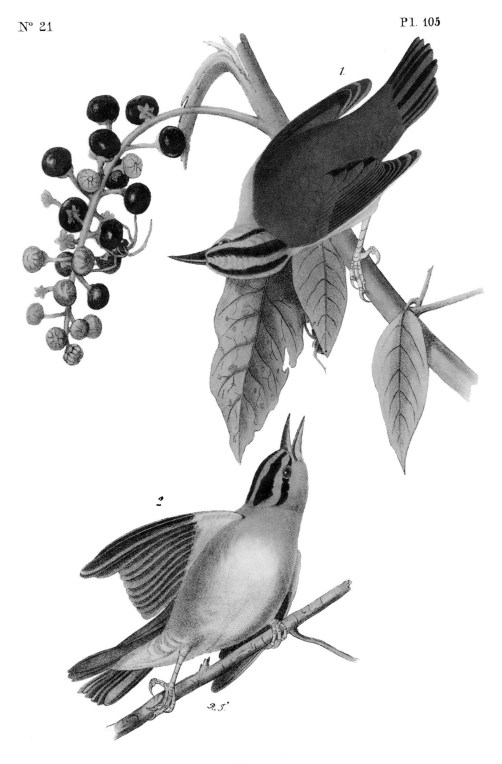

Worm-eating Swamp Warbler.

1. Male. 2. Female.

American Poke-weed. Phytolacca decandra.

Drawn from Nature by J.J.Audubon,F.R.S.,F.L.S.

Lithd Printed & Cold by J.T.Bowen.Philadª

Pl. 107. Golden-winged Swamp Warbler

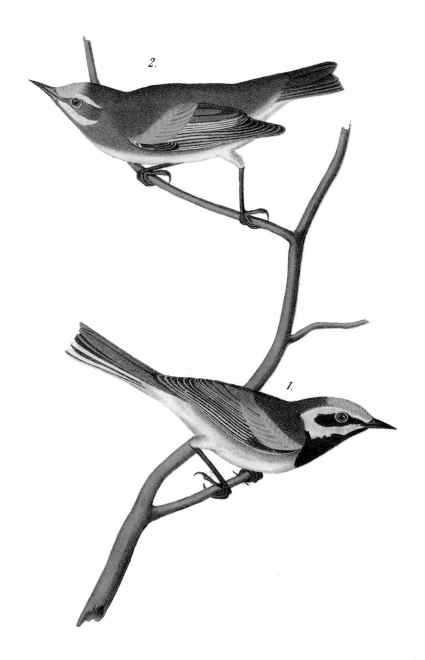

Golden-winged Swamp-Warbler.
1 Male. 2 Female.

Drawn from Nature by J.J.Audubon, F.R.S.F.L.S.

Lith⁴ Printed & Col⁴ by J.T.Bowen. Philad⁴

Pl. 108. Bachman's Swamp Warbler

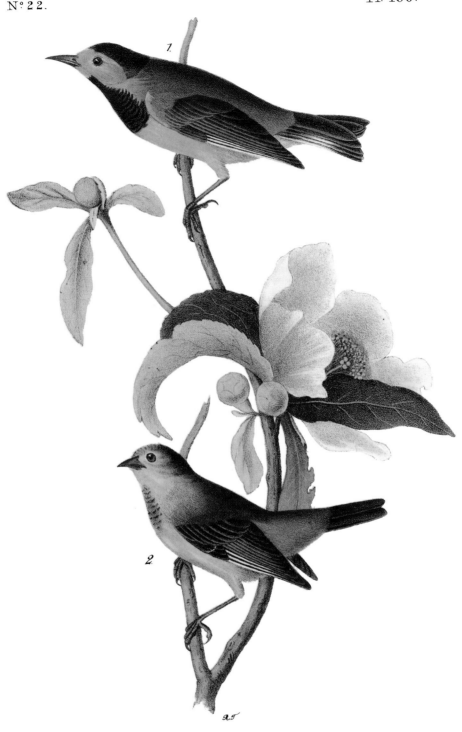

Bachman's Swamp-Warbler.

1. *Male.* 2. *Female.*

Gordonia pubescens.

Drawn from Nature by J. J. Audubon, F. R. S. F. L. S.

Lith⁴ Printed & Col⁴ by J. T. Bowen, Philad⁴

Pl. 109. Carbonated Swamp Warbler

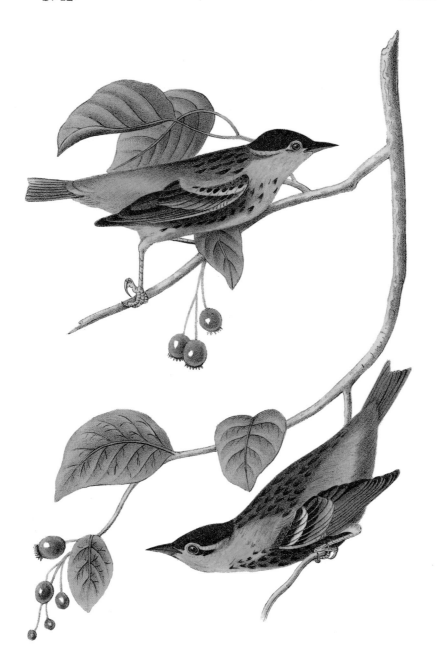

Carbonated Swamp-Warbler
Males
May-bush or Service Pyrus Botryapium.

Drawn from Nature by J.J.Audubon, F.R.S.F.L.S. Lith.ª Printed & Col.d by J.T.Bowen, Philad.ª

Pl. 111. Blue-winged Yellow Swamp Warbler

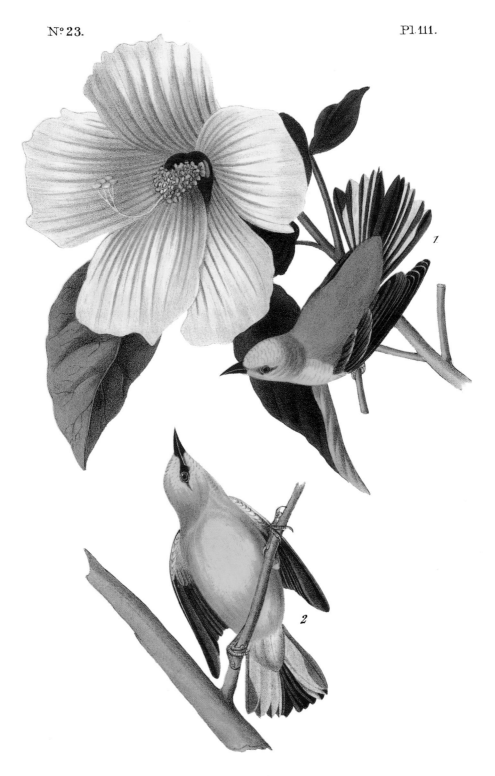

R.T.

Blue-winged Yellow Swamp Warbler.

1. Male 2. Female

Cotton Rose. Hibiscus grandiflorus.

Drawn from Nature by J.J.Audubon.F.R.S.F.L.S. Lithd Printed & Cold by J.T. Bowen. Philada

Pl. 120. House Wren

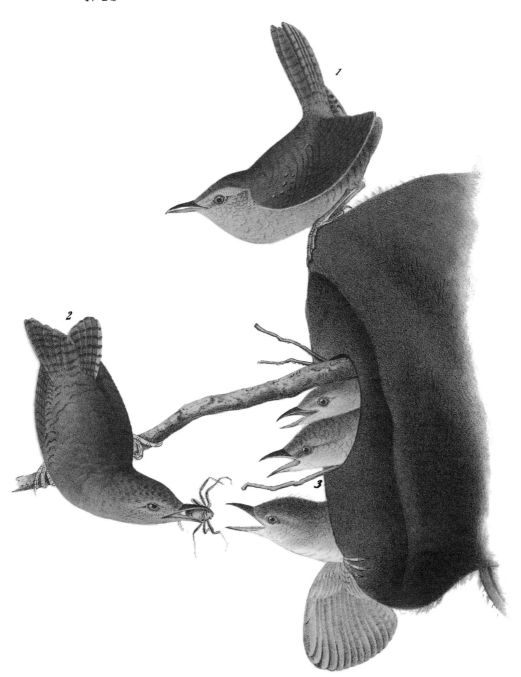

R.T.

House Wren

1. Male. 2. Female 3. Young
In an old Hat.

Drawn from Nature by J.J.Audubon, F.R.S.F.L.S. Lith⁴ Printed & Col⁴ by J.T.Bowen.Philad⁴

Pl. 121. Winter Wren

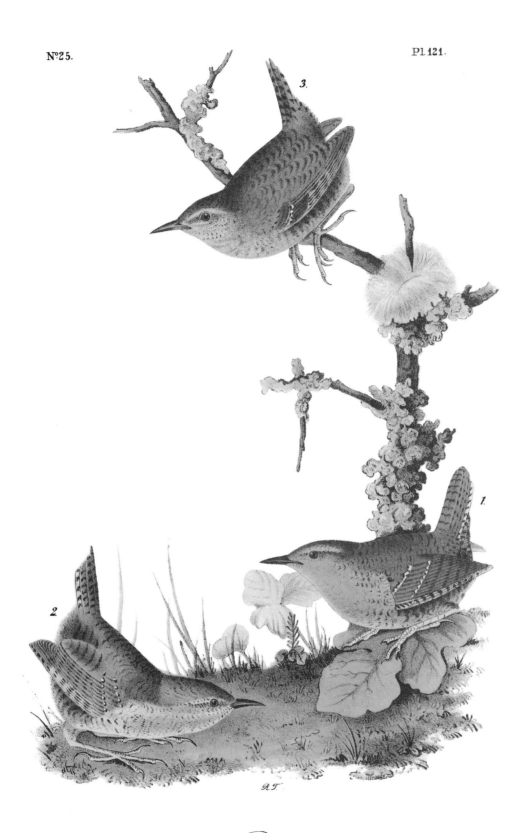

Winter Wren.

1. Male. 2. Female. 3. Young.

Drawn from Nature by J. J. Audubon F.R.S.F.L.S.

Pl. 123. Marsh Wren

Pl. 123.

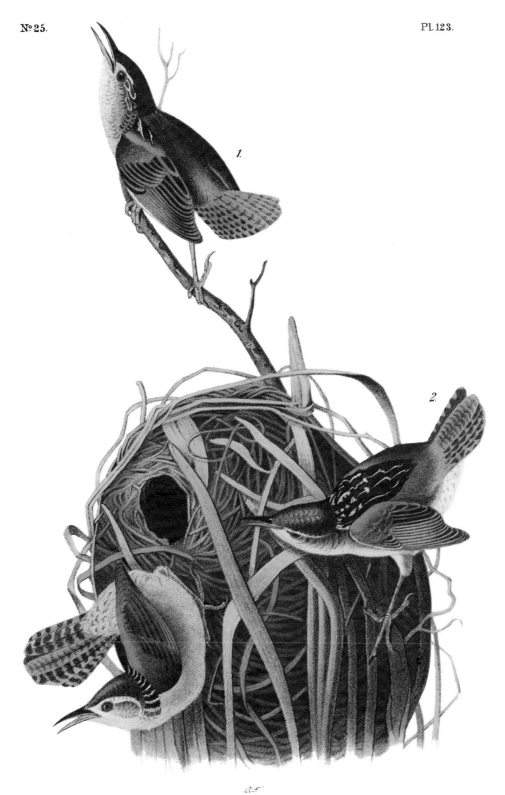

Marsh Wren.

1. *Males 2 Female and Nest*

Drawn from Nature by J. J. Audubon F.R.S.F.L.S.

Lith. Printed & Col.d by J. T. Bowen, Philad.a

Pl. 125. Crested Titmouse

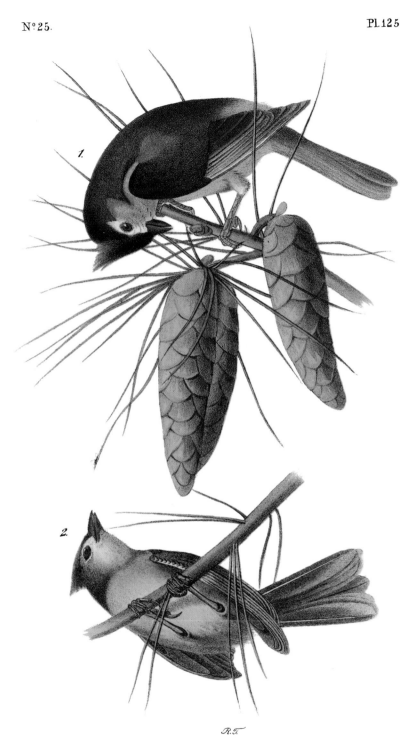

Crested Titmouse

1. Male 2. Female.
White Pine. Pinus Strobus.

Drawn from Nature by J.J. Audubon. F.R.S.F.L.S.

Lithᵈ Printed & Colᵈ by J.T. Bowen. Philadᵃ

Pl. 127. Carolina Titmouse

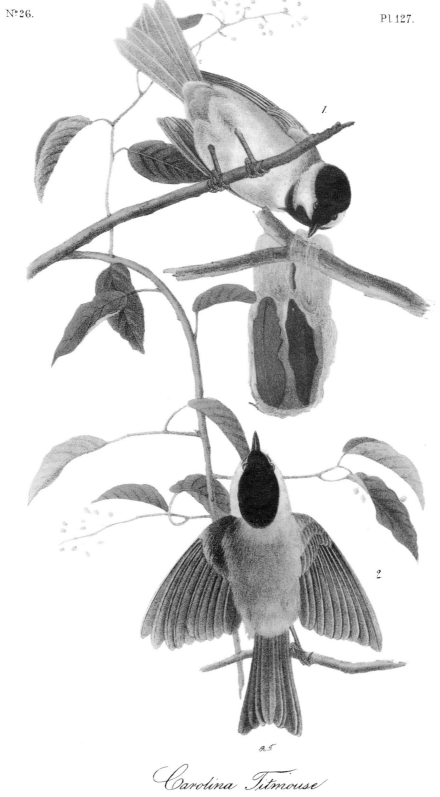

1.

2.

R.5.

Carolina Titmouse

1. Male 2. Female.

Supple Jack.

Drawn from Nature by J.J.Audubon.F.R.S.F.L.S.

Lith.d Printed & Col.d by J.T.Bowen Philad.a

Pl. 130. Chestnut-crowned Titmouse

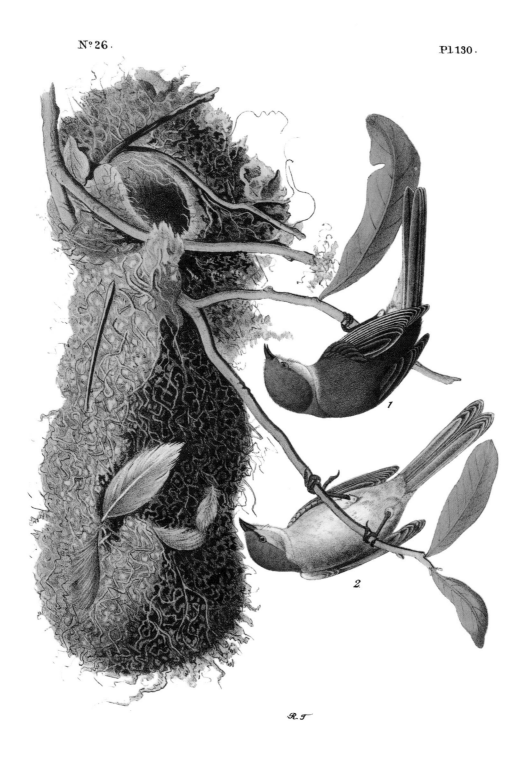

1

2

R. T

Chesnut-crowned Titmouse

1. Male. 2. Female and Nest.

Drawn from Nature by J.J.Audubon.F.R.S.F.L.S.

Lithd Printed & Cold by J.T.Bowen.Philada

Pl. 132. American Golden-crested Kinglet

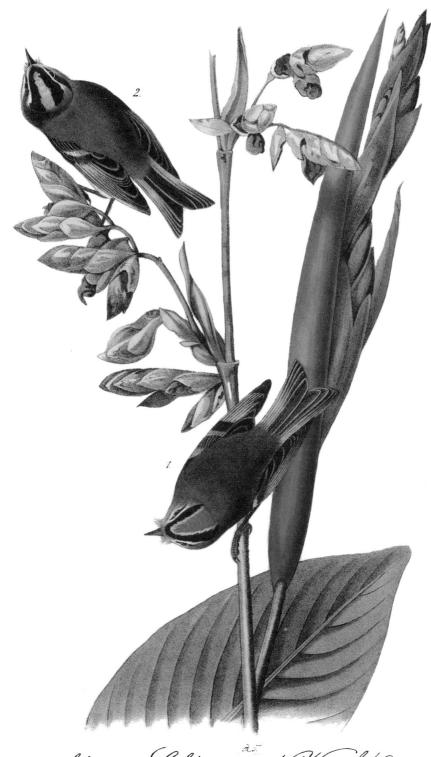

American Golden-crested Kinglet.

1. Male. 2. Female.

Thalia dealbata.

Drawn from Nature by J.J.Audubon.FRSFLS.

Lith.^d Printed & Col.^d by J. T Bowen Philad.^a

Pl. 134. Common Blue Bird

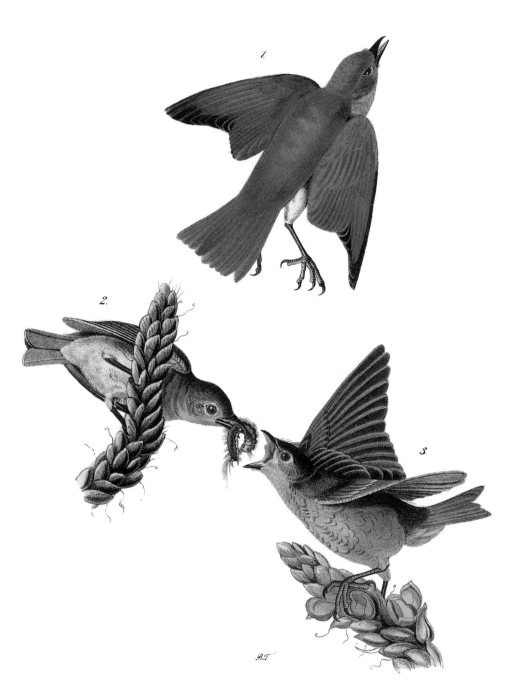

Common Blue Bird

1. Male. 2. Female. 3 Young.
Great Mullein Verbascum Thapsus.

Drawn from Nature by J.J.Audubon.F.R.S.F.L.S Lith.d Printed & Col.d by J.T.Bowen.Philad.a

Pl. 136. Arctic Blue Bird

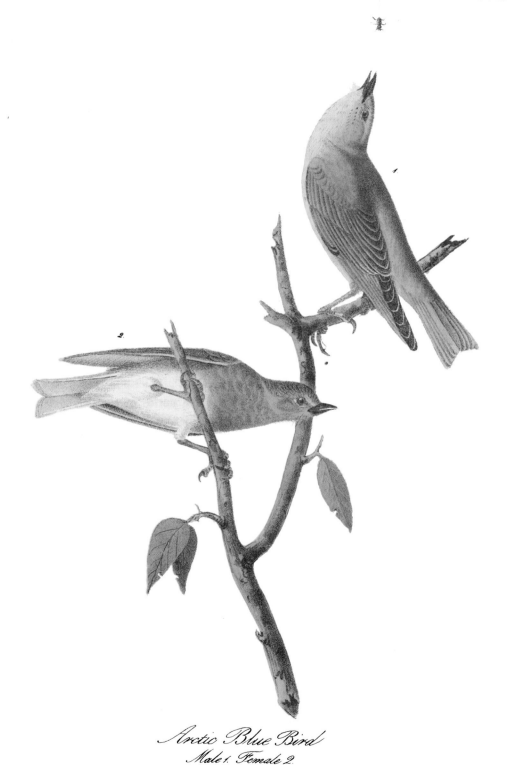

Arctic Blue Bird
Male 1. Female 2.

Drawn from nature by J.J. Audubon F.R.S F.L.S.

Lith. & Printed by Endicott New York.

Pl. 138. Common Mocking Bird

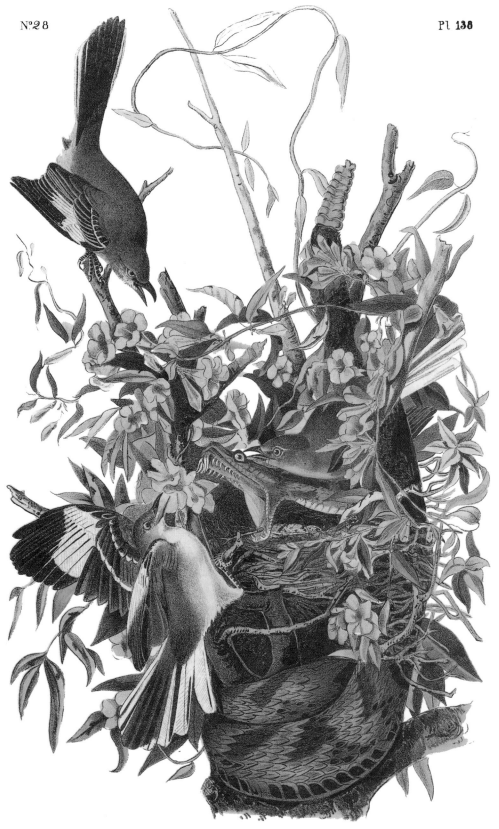

Common Mocking Bird
Males 1 & 2 Female 3,
Florida Jessamine, Gelseminum niditum
Rattlesnake

Drawn from nature by J.J. Audubon F.R.S.F.L.S.

Lith. & Printed by Endicott New York.

Pl. 141. Ferruginous Mocking Bird

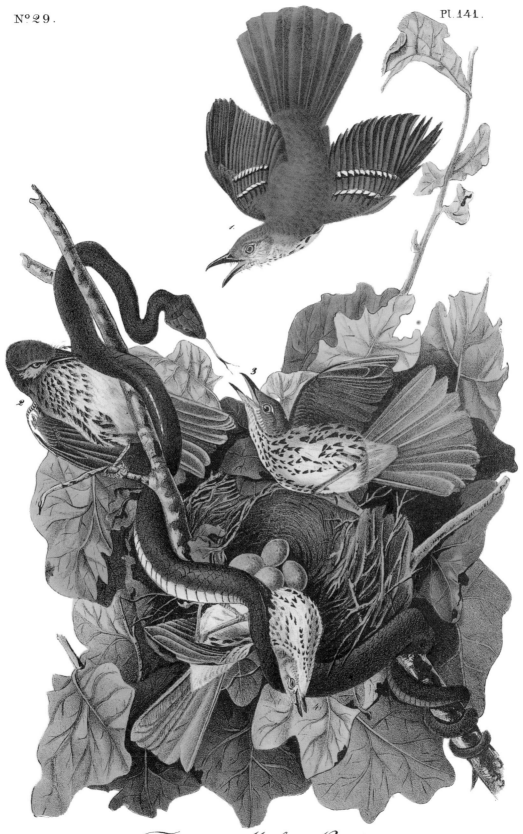

Ferruginous Mocking Bird
Males 1, 2, 3, Female 4.

Drawn from nature by J.J. Audubon F.R.S.F.L.S.

Lith & Printed by Endicott New York.

Pl. 142. American Robin or Migratory Thrush

Pl. 142.

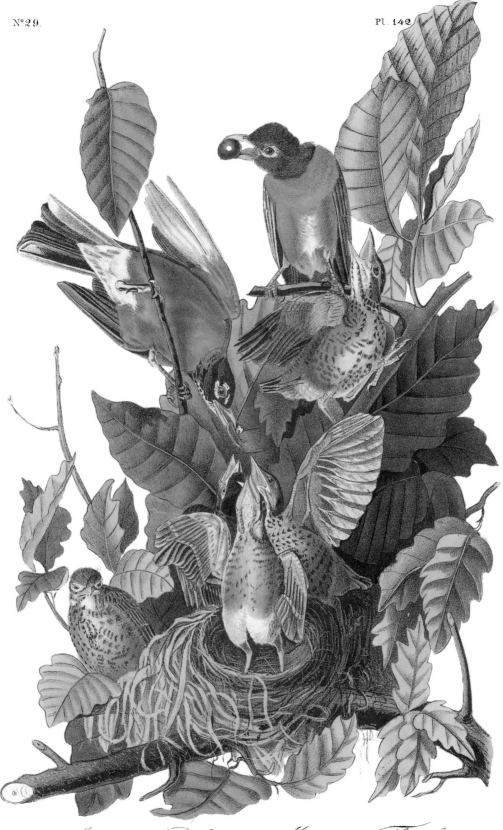

American Robin, or Migratory Thrush.
Male 1. Female 2 and young

Chesnut Oak Quercus prinus.

Drawn from nature by J.J. Audubon.F.R.S.F.L.S. Lith. & Printed by Endicott New York

Pl. 148. Golden-Crowned Wagtail

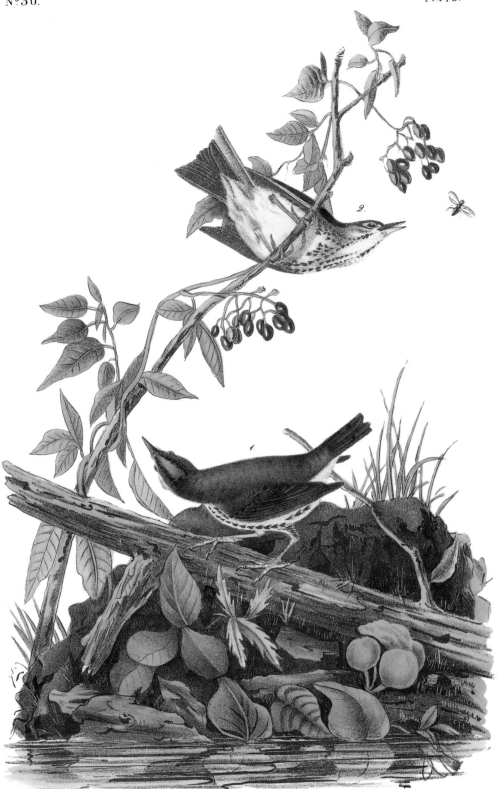

Golden Crowned Wagtail (Thrush.)
Male 1. Female 2.
Plant Woody Nightshade.

Drawn from nature by J.J. Audubon F.R.S.F.L.S. Lith. & Printed by Endicott New York.

Pl. 154. Chestnut-collared Lark Bunting

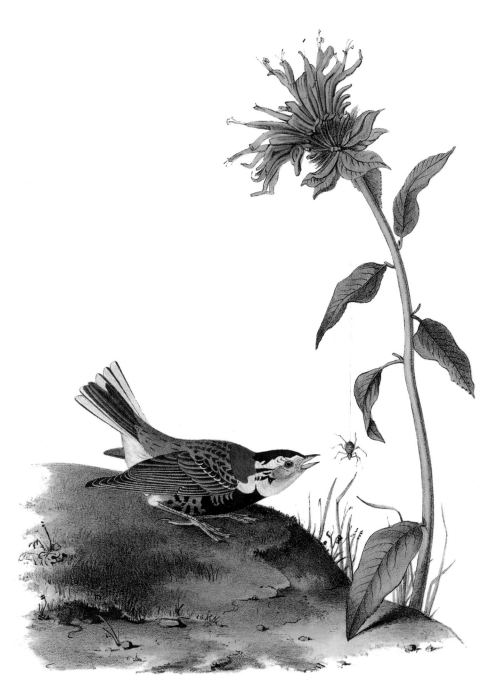

R.T.

Chesnut-collared Lark-Bunting.

Male.

Drawn from Nature by J.J. Audubon. F.R.S.F.L.S. Lith.ᵈ Printed & Col.ᵈ by J.T. Bowen, Philad.ᵃ

Pl. 155. Snow Lark Bunting

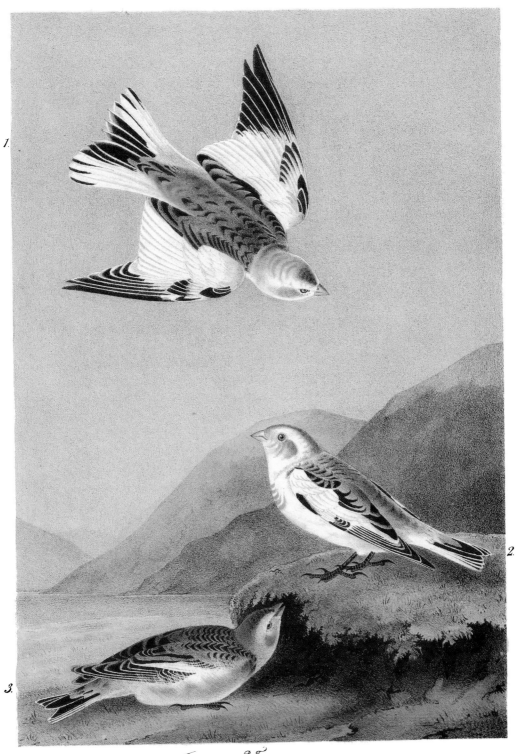

Snow Lark Bunting

1. 2. Adult. 3. Young.

Drawn from Nature by J.J. Audubon, F.R.S.F.L.S. Lith.ᵈ Printed & Col.ᵈ by J.T. Bowen, Philad.ᵃ

Pl. 167. Common Snow Bird

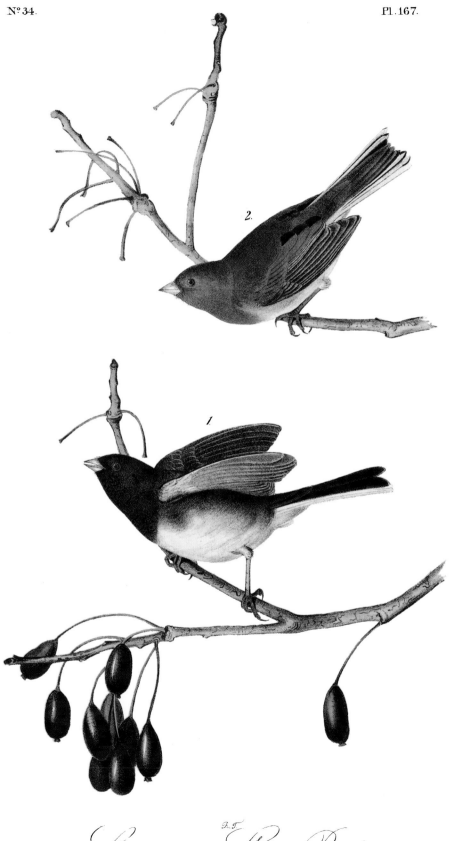

Common Snow-Bird.

1. Male. 2. Female

Drawn from Nature by J. J. Audubon ERSFLS

Lithᵈ Printed & Colᵈ by J T Bowen Philad

Pl. 169. Painted Bunting

Pl.169.

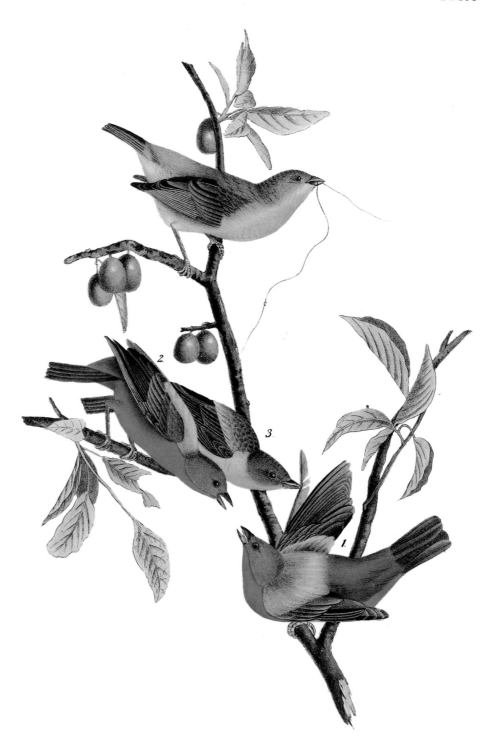

Painted Bunting

1. 2. 3. Males in different States of Plumage. 4.Female.

Chicasaw Wild Plum.

Drawn from Nature by J. J. Audubon. F. R. S. F. L.S. Lith.ᵈ Printed & Col.ᵈ by J. T. Bowen Philad.ᵃ

Pl. 174. Sharp-tailed Finch

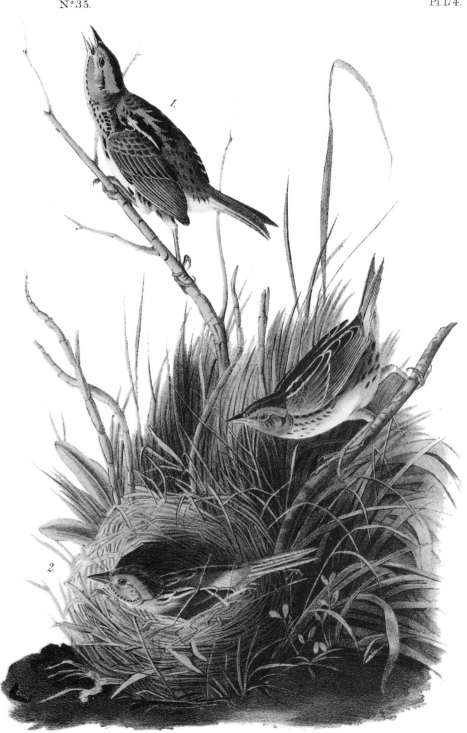

R. T.

Sharp-tailed Finch.

1. Males. 2. Female & Nest.

Drawn from Nature by J. J. Audubon, F.R.S.F.L.S.

Lith.ᵈ Printed & Col.ᵈ by J. T. Bowen, Philad.ᵃ

Pl. 177. Lincoln's Pinewood Finch

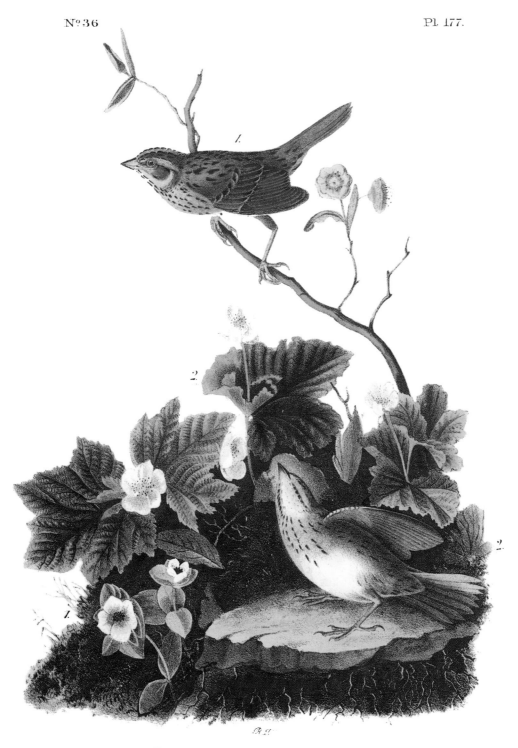

Lincoln's Pinewood Finch.

1. Male. 2. Female.

1. Dwarf Cornel. 2. Cloudberry 3. Glaucous Kalmia.

Drawn from Nature by J.J.Audubon F.R.S.F.L.S. Lith.d Printed & Col.d by J.T.Bowen Philad.

Pl. 184. Yarrell's Goldfinch

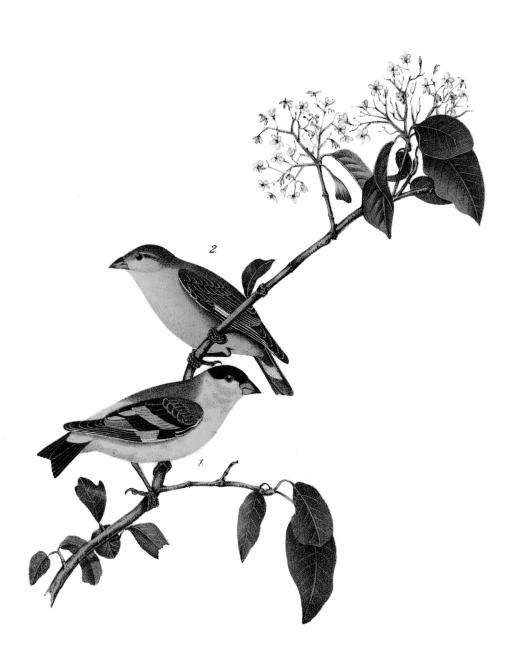

Yarrell's Goldfinch

1 Male 2 Female.

Drawn from Nature by J.J.Audubon.F.R.S.F.L.S. Lith.d Printed & Col.d by J.T.Bowen Philad.

Pl. 191. White-throated Finch

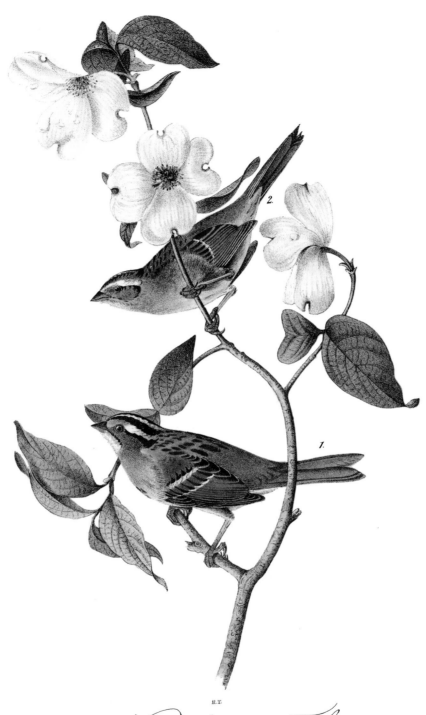

R.T.

White-throated Finch.

1. Male 2. Female

Common Dogwood

Drawn from Nature by J.J. Audubon, F.R.S. F.L.S.

Lith⁴ Printed & Col⁴ by J. T. Bowen, Philad.

Pl. 192. White-crowned Finch

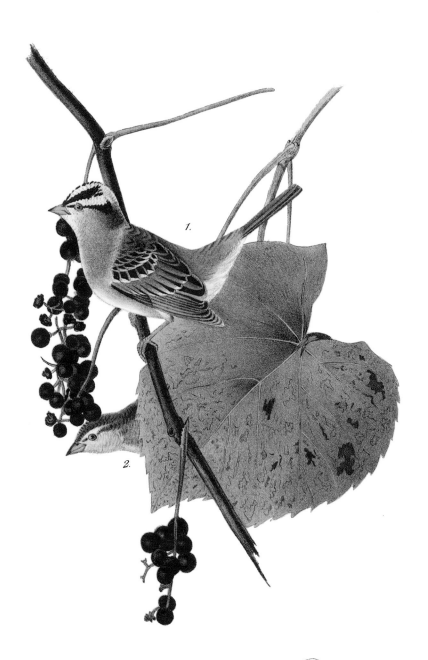

White-crowned Finch.

1. Male. 2. Female.

Wild Summer Grape.

Drawn from Nature by J.J.Audubon. F.R.S.F.L.S. Lith.d Printed & Col.d by J.T. Bowen, Philad.a

Pl. 195. Towhe Ground Finch

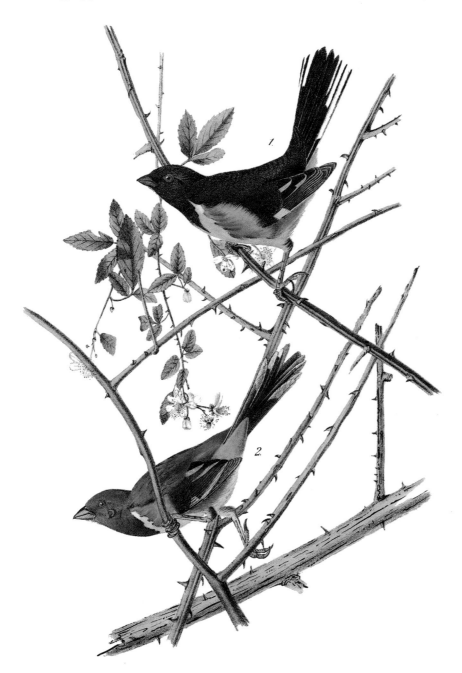

Towhe Ground Finch

1. Male 2. Female
Common Blackberry

Drawn from Nature by J.J.Audubon.F.R.S.F.L.S. Lith.d Printed & Col.d by J.T.Bowen.Philad.

Pl. 196. Crested Purple Finch

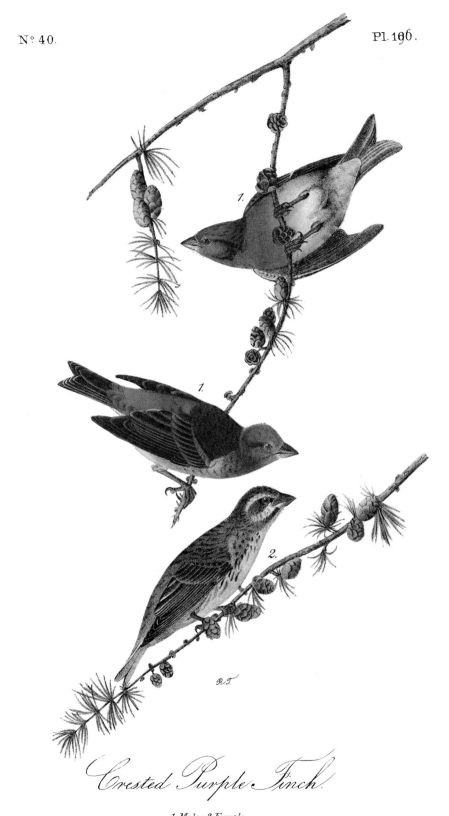

1.

1.

2.

R.T.

Crested Purple Finch.

1 Males. 2 Female.

Red Larch Larix Americana.

Drawn from Nature by J.J.Audubon. F.R.S.F.L.S.

Lith.ᵈ Printed & Col.ᵈ by J.T.Bowen. Philad.ᵃ

Pl. 201. White-winged Crossbill

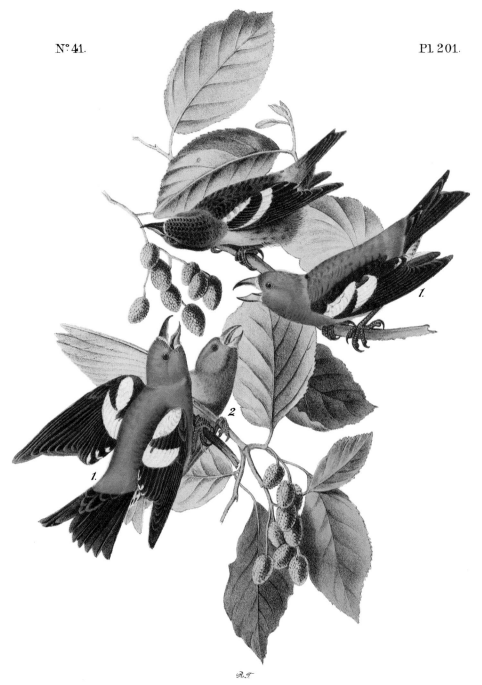

R.T

White-winged Crossbill.

1. Males 2. Females.

Drawn from Nature by J. J. Audubon, F.R.S.F.L.S

Lith.ª Printed & Col.ª by J. T. Bowen, Philad.

Pl. 203. Common Cardinal Grosbeak

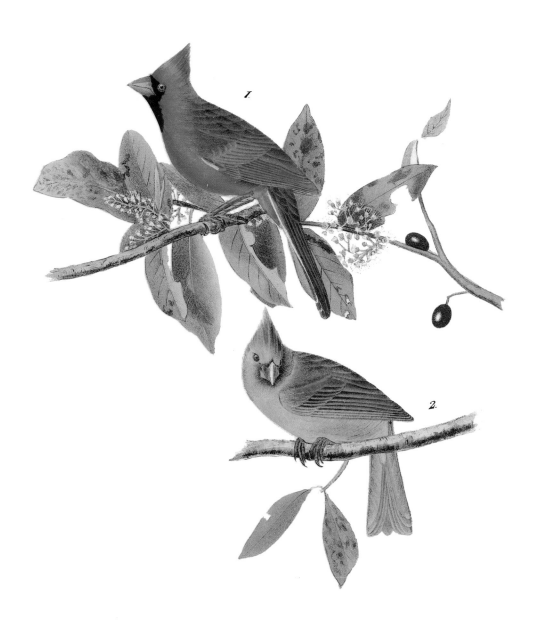

Common Cardinal Grosbeak.

1. Male. 2. Female.

Wild Almond, Prunus caroliniana.

Drawn from Nature by J.J.Audubon.F.R.S.F.L.S. Lithd,Printed & Cold by J.T.Bowen.Phil.

Pl. 205. Rose-breasted Song Grosbeak

Pl. 205.

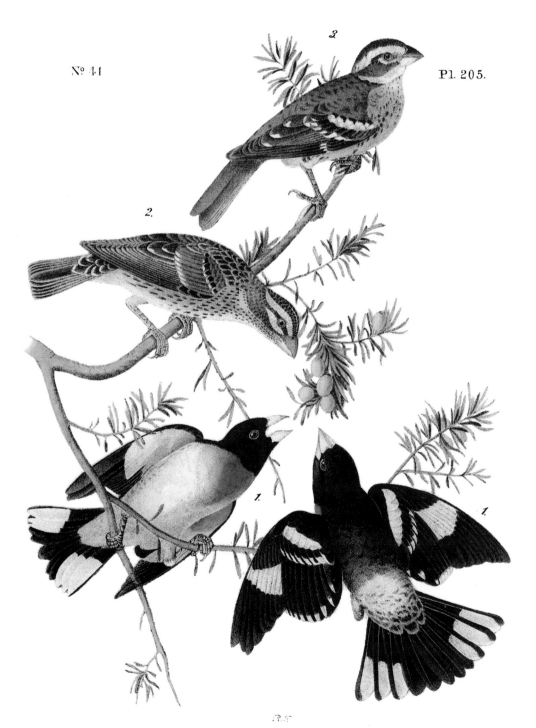

Rose-breasted Song-Grosbeak.

1. Males. 2. Female. 3. Young Male.
Ground Hemlock. Taxus canadensis.

Drawn from Nature by J.J. Audubon. FRSFLS. Lith⁴ Printed & Col⁴ by J.T. Bowen, Phil.

Pl. 208. Summer Red-bird

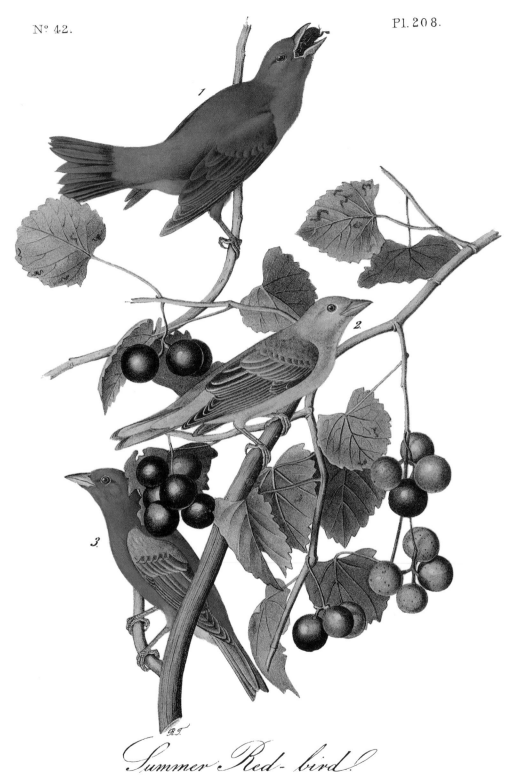

Summer Red-bird!

1. Male. 2. Female. 3. Young Male.
Wild Muscadine Vitis rotundifolia Mich.

Drawn from Nature by J.J. Audubon. F.R.S.F.L.S. Lithd Printed & Cold by J. T. Bowen. Philad.

Pl. 214. Red-and-white-shouldered Marsh Blackbird

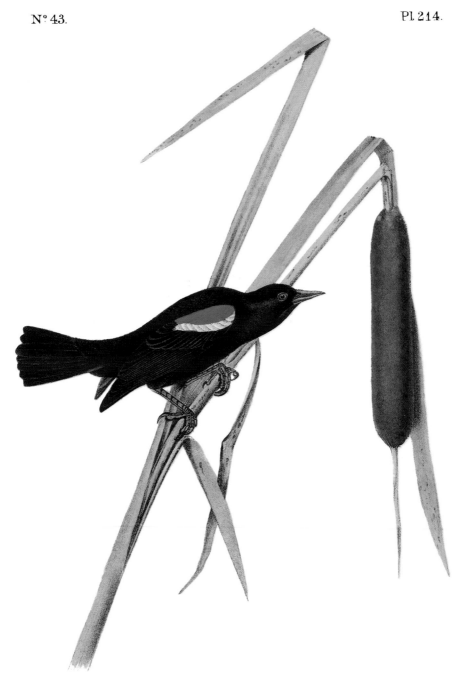

Red-and-white-shouldered Marsh Blackbird.

Male.

Drawn from Nature by J.J.Audubon. F.R.S.F.L.S.

Lith.ᵈ Printed & Col.ᵈ by J. T. Bowen. Philad.

Pl. 215. Red-and-black-shouldered Marsh Blackbird

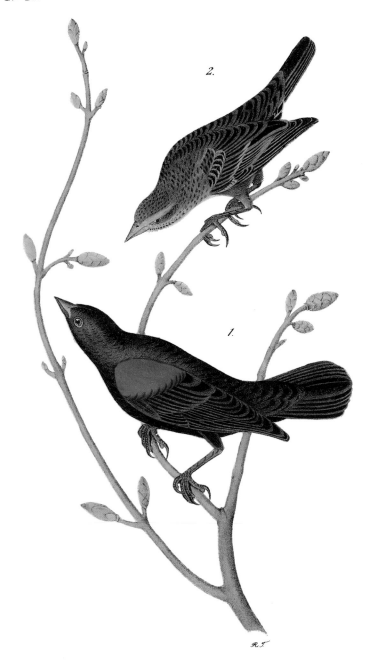

Red and black-shouldered Marsh Blackbird.

1. Male 2. Female.

Drawn from Nature by I.J. Audubon F.R.S. F.L.S.

Lith.ᵈ Printed & Col.ᵈ by J.T. Bowen. Philad.

Pl. 216. Red-winged Starling

Pl. 216.

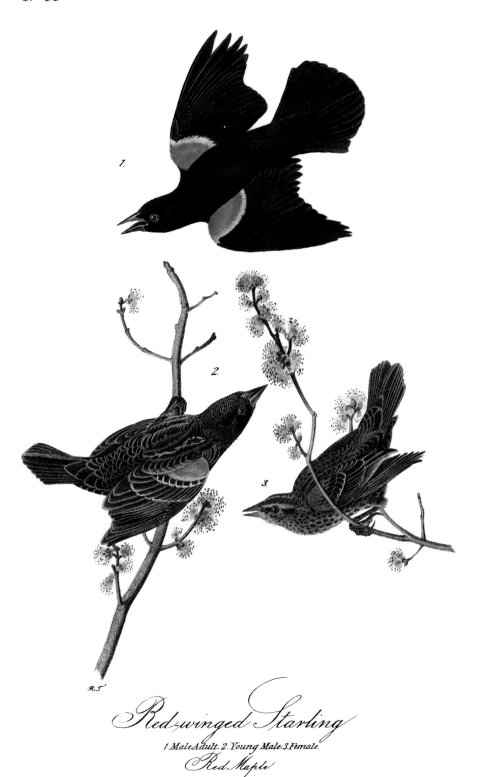

Red-winged Starling

1. Male Adult. 2. Young Male. 3. Female.

Red Maple

Drawn from Nature by J.J. Audubon.F.R.S.FLS. Lith.^d Printed & Col.^d by J.T.Bowen. Philad.

Pl. 217. Baltimore Oriole or Hang Nest

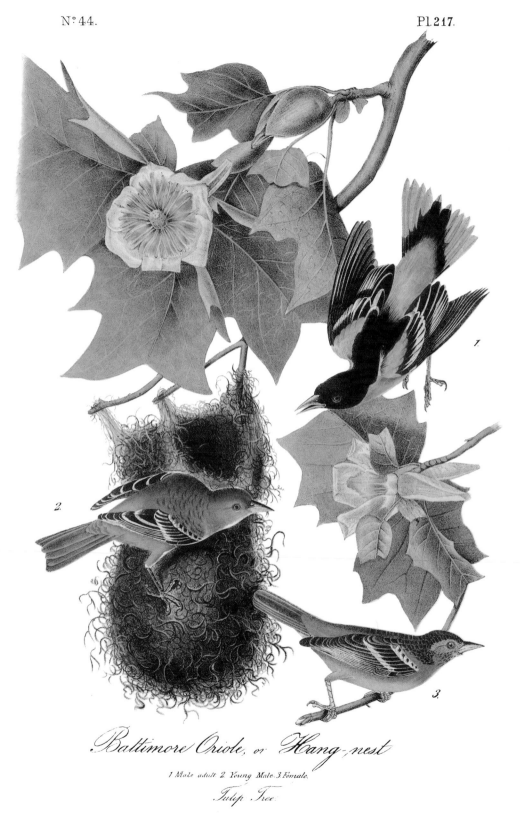

Baltimore Oriole, or Hang-nest.

1 Male adult. 2 Young Male. 3 Female.

Tulip Tree.

Drawn from Nature by J. J. Audubon. F.R.S.F.L.S. Lith.d Printed & Col.d by J. T. Bowen. Phil.

Pl. 220. Boat-tailed Grackle

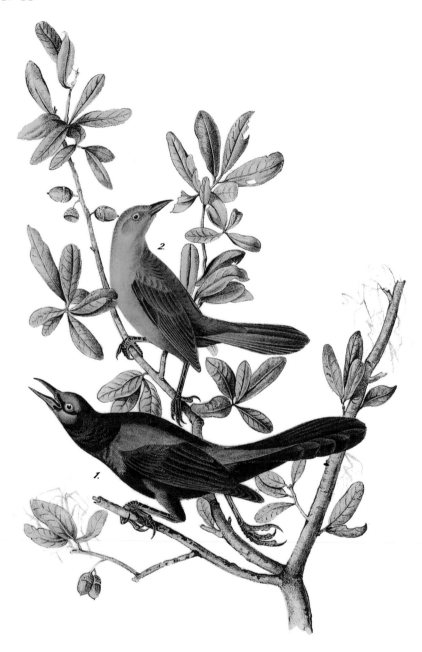

Boat-tailed Grackle.

1. Male. 2. Female.

Live Oak.

Drawn from Nature by J.J.Audubon.F.R.S.F.L.S Lithd Printed & Cold by J.T.Bowen.Phil.

Pl. 221. Common or Purple Crow Blackbird

Pl. 221.

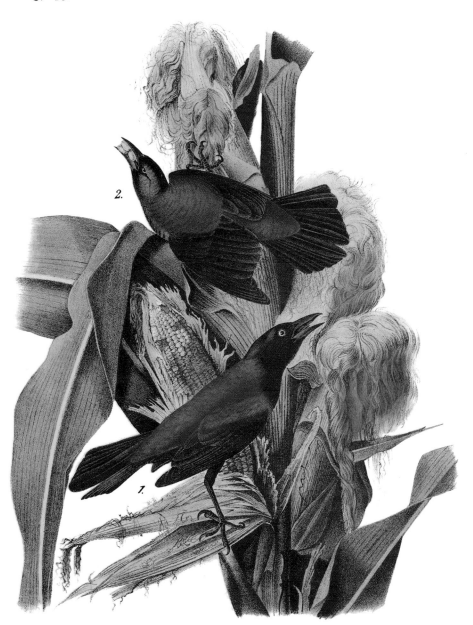

Common, or Purple Crow-Blackbird.

1 Male. 2 Female.

Maize or Indian Corn.

Drawn from Nature by J. J. Audubon. F. R. S. F. L. S.

Lith⁴ Printed & Col⁴ by J. T. Bowen. Philad.

Pl. 224. Raven

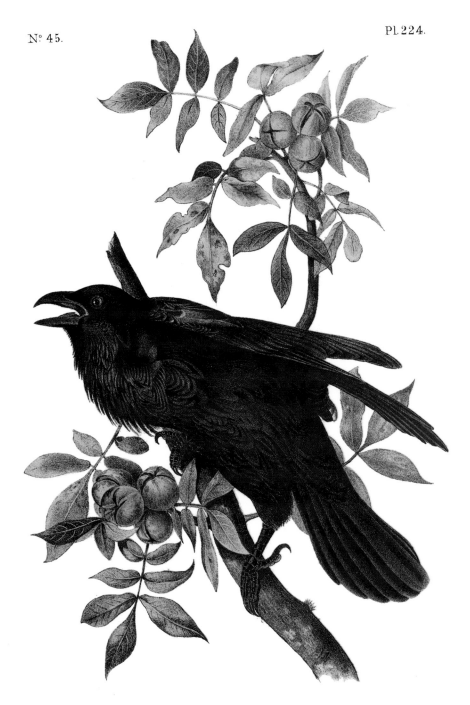

Raven

Old Male.
Thick Shell bark Hickory

Drawn from Nature by J.J. Audubon. F.R.S.F.L.S. Lith⁴ Printed & Col⁴ by J.T. Bowen. Philad.

Pl. 225. Common American Crow

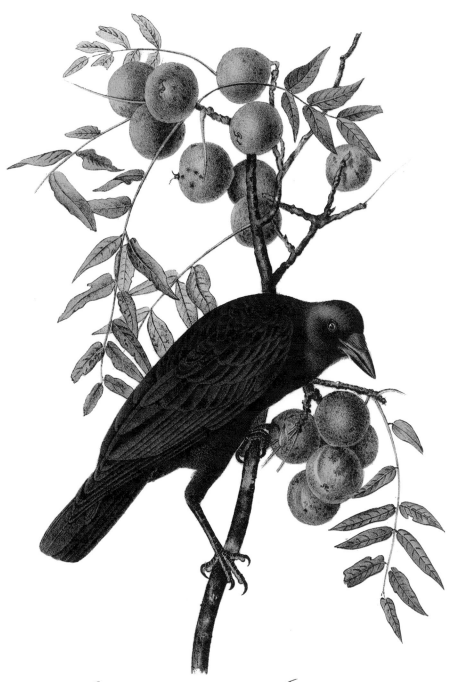

Common American Crow.

Male.

Black Walnut.

Drawn from Nature by J. J. Audubon. F.R.S.F.L.S Lith.ᵈ Printed & Col.ᵈ by J. T. Bowen. Phil

Pl. 227. Common Magpie

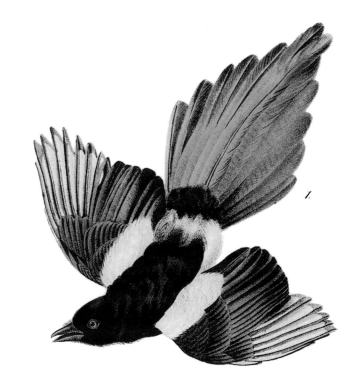

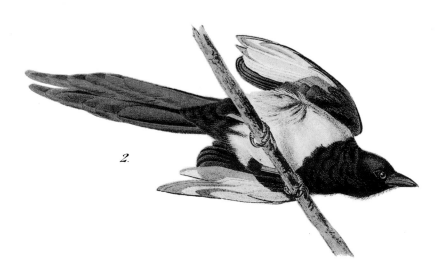

Common Magpie.

1. Male 2. Female.

Drawn from Nature by J.J.Audubon.F.R.S.F.L.S

Lith.ᵈ Printed & Col.ᵈ by J.T.Bowen Philad.

Pl. 229. Columbia Magpie or Jay

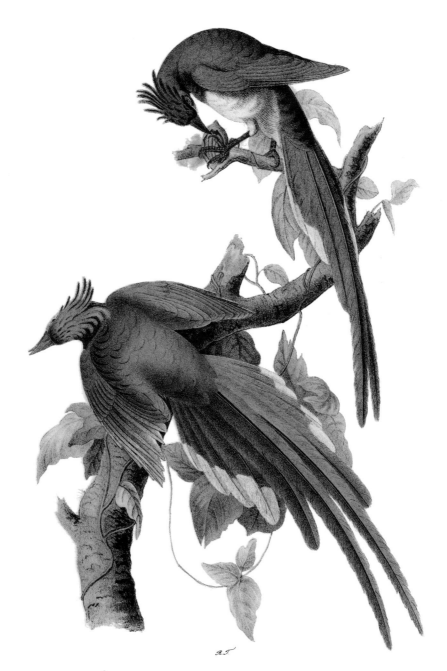

Columbia Magpie or Jay.
Males

Drawn from Nature by J. J. Audubon. F R S F L S. Lithd Printed & Cold by J. T. Bowen. Phil.

Pl. 231. Blue Jay

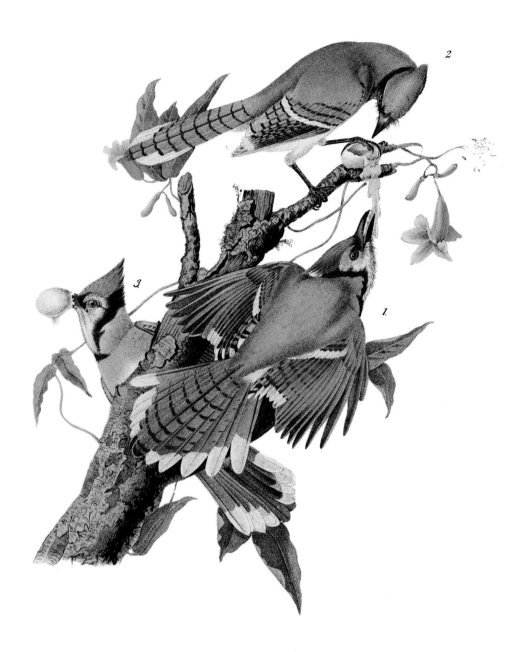

Blue Jay

1. Male. 2 & 3. Female.

Trumpet flower. Bignonia radicans.

Drawn from Nature by J.J.Audubon. F.R.S.F.L.S. Lith⁴ Printed & Col⁴ by J.T.Bowen. Philad.

Pl. 233. Florida Jay

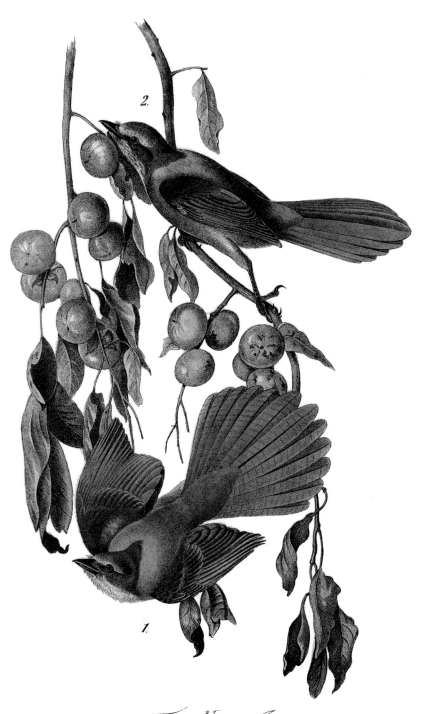

Florida Jay.
1. Male. — 2. Female.
Persimon tree. Diospyros Virginiana.

Drawn from Nature by J.J.Audubon.F.R.S.F.L.S. Lithd. Printed & Cold. by J. T. Bowen. Phil.

Pl. 235. Clarke's Nutcracker

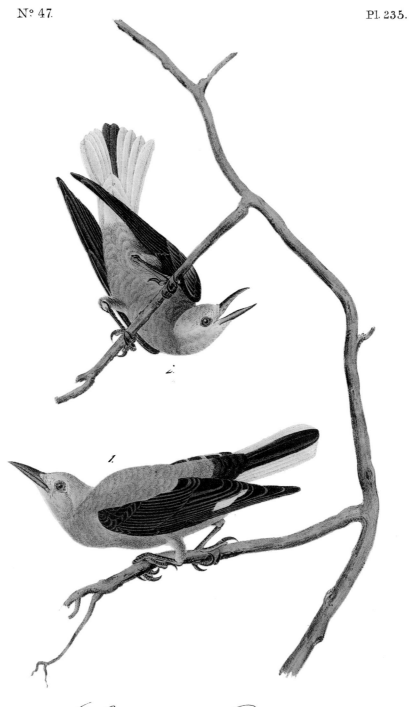

Clarke's Nutcracker.

1. Male. 2. Female.

Drawn from Nature by J.J.Audubon. F.R.S.F.L.S Lith.ᵈ Printed & Col.ᵈ by J.T.Bowen.Philad.

Pl. 243. Red-eyed Vireo or Greenlet

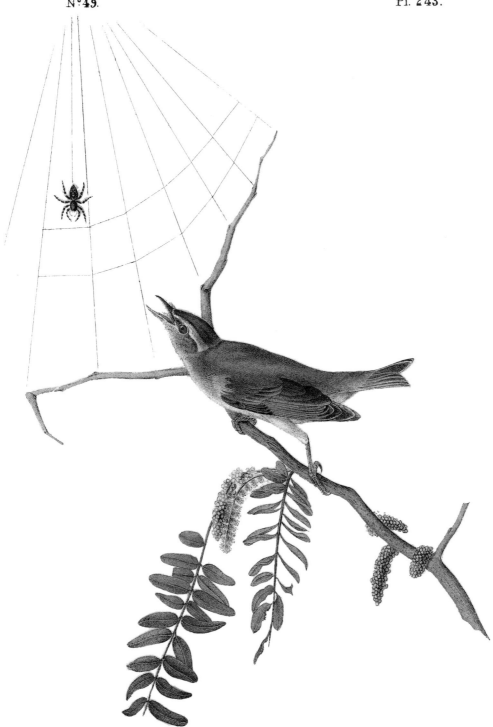

Red-eyed Vireo or Greenlet.

Male.

Honey-locust.

Drawn from Nature by J.J.Audubon. F.R.S.F.L.S. Lith.d Printed & Col.d by J.T.Bowen. Phil.

Pl. 248. Red-bellied Nuthatch

Pl. 248.

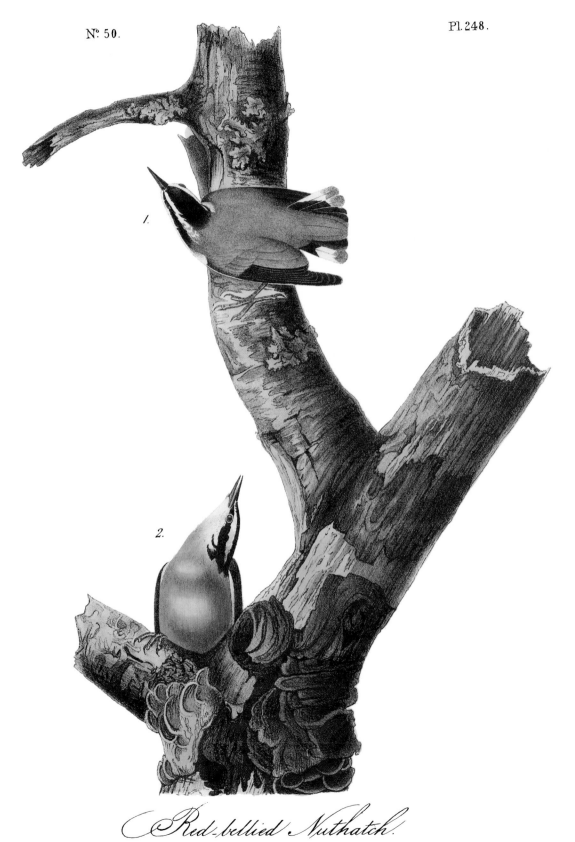

Red-bellied Nuthatch.

1. Male. 2. Female.

Drawn from Nature by J.J. Audubon. F.R.S.F.L.S. Lithd. Printed & Cold. by J.T. Bowen. Phil.

Pl. 251. Mango Humming Bird

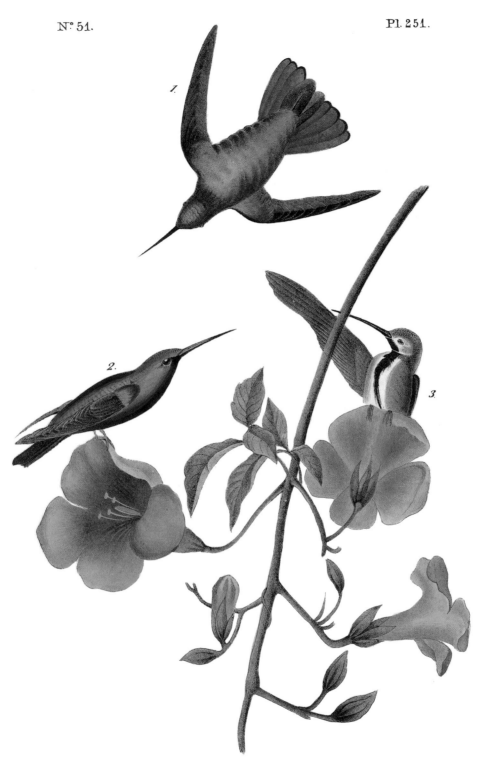

Mango Humming bird

1. 2. Males. 3. Female
Bignonia grandifolia.

Drawn from Nature by J.J.Audubon. F.R.S.F.L.S.

Lithᵈ Printed & Colᵈ by J.T.Bowen. Phil.

Pl. 252. Anna Humming Bird

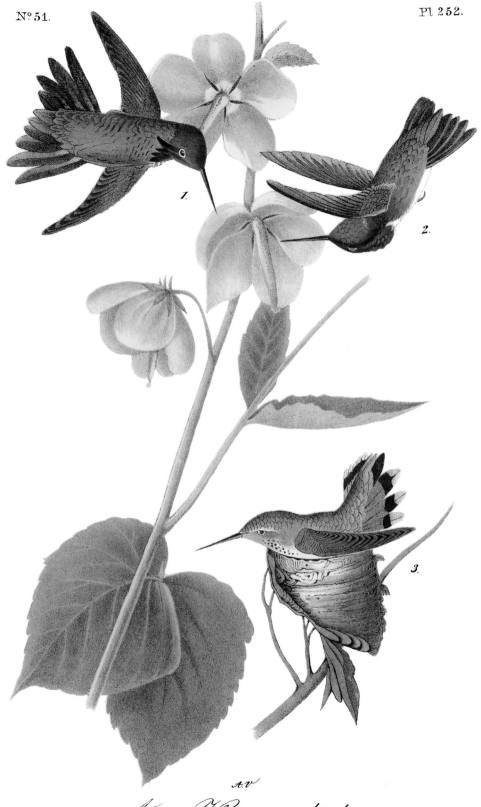

1.

2.

3.

A.V

Anna Humming bird.

1. 2. Males. 3. Female.

Hibiscus Virginicus.

Drawn from Nature by J.J. Audubon. F.R.S.F.L.S. Lith. Printed & Col.^d by J.T. Bowen Phil.

Pl. 253. Ruby-throated Humming Bird

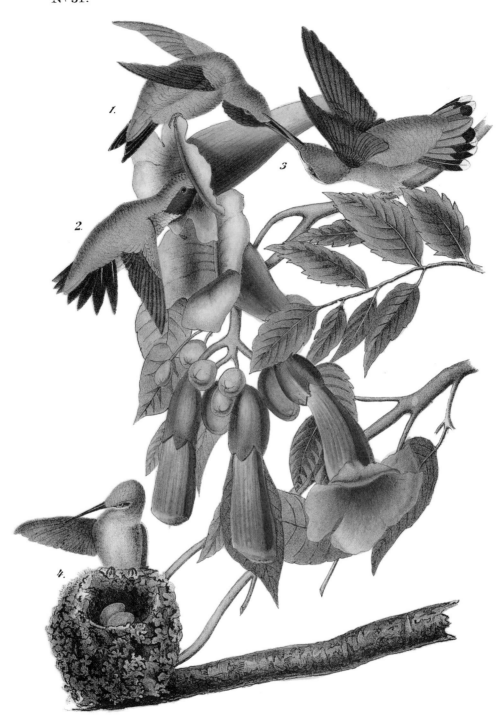

Ruby-throated Hummingbird.

1. 2. Males . 3. Female. — 4 Young

Bignonia - radicans

Drawn from Nature by J.J.Audubon. F.R.S.F.L.S. Lith.d Printed & Col.d by J. T. Bowen. Phil.a

Pl. 255. Belted Kingfisher

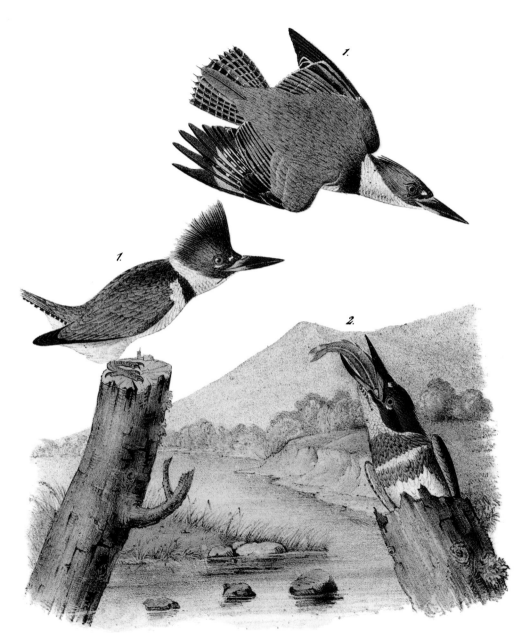

W. H.

Belted Kingfisher

Alcedo Alcyon.

1. Males 2. Female

Drawn from Nature by J.J.Audubon.F.R.S.F.L.S.

Lith⁴ Printed & Col⁴ by J.T. Bowen. Phil.

Pl. 257. Pileated Woodpecker

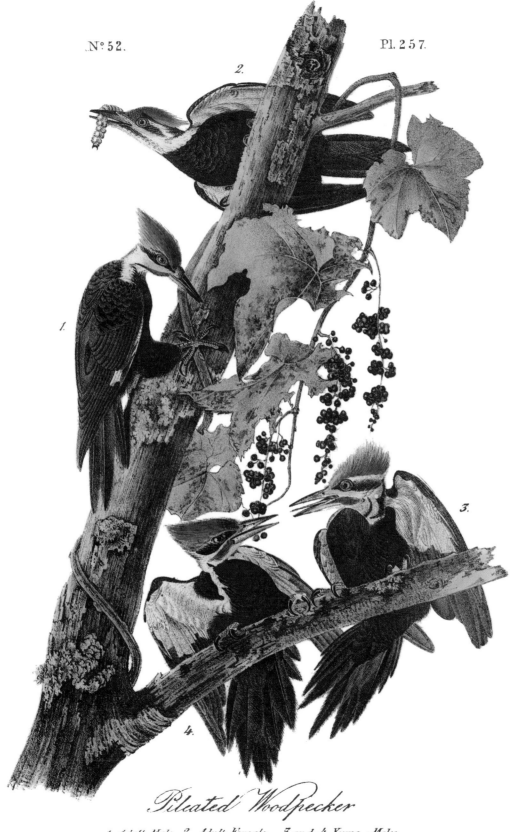

Pileated Woodpecker

1. Adult Male. 2. Adult Female. 3 and 4. Young Males.

Raccoon Grape.

Drawn from Nature by J. J. Audubon, F.R.S.F.L.S. Lithd Printed & Cold by J. T. Bowen, Phil.

Pl. 268. Arctic Three-toed Woodpecker

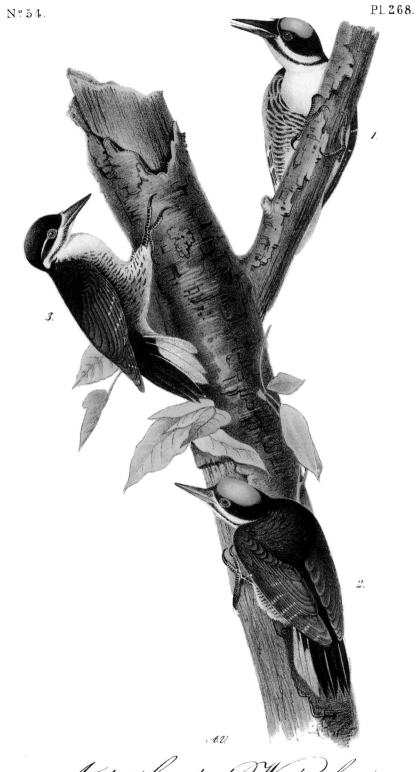

Arctic three-toed Woodpecker.

1. 2. Males. 3. Female.

Drawn from Nature by J.J.Audubon.F.R.S.F.L.S.

Lith.ᵈ Printed & Col.ᵈ by J. T. Bowen. Phil.

Pl. 270. Red-bellied Woodpecker

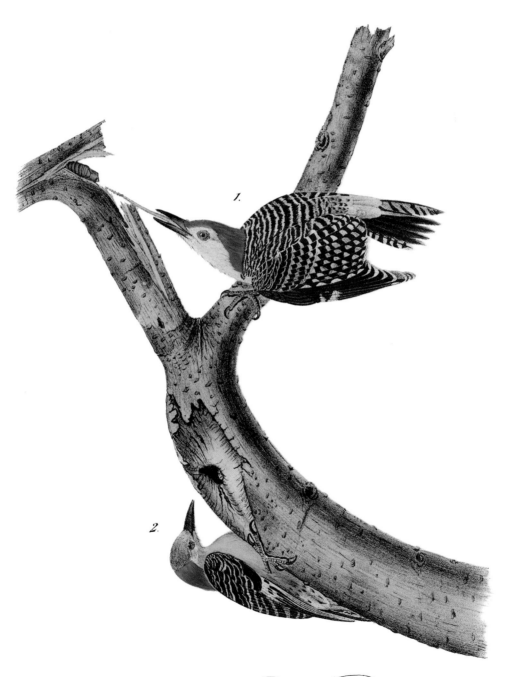

Red-bellied Woodpecker.

1. Male. 2. Female.

Drawn from Nature by J. J. Audubon. F.R.S.F.L.S. Lithd. Printed & Cold. by J. T. Bowen. Phil.

Pl. 271. Red-headed Woodpecker

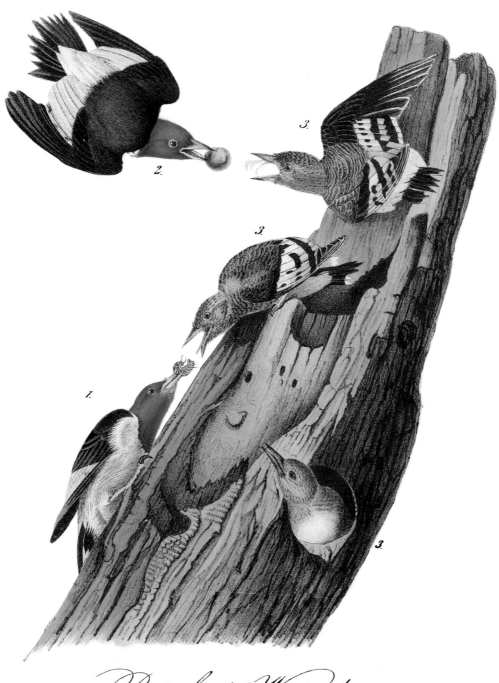

Red-headed Woodpecker.

1.Male. 2.Female. 3.Young.

Drawn from Nature by J.J.Audubon.F.R.S.F.L.S.

Lith.ᵈPrinted &Col.ᵈby J.T.Bowen.Phil.

Pl. 273. Golden-winged Woodpecker

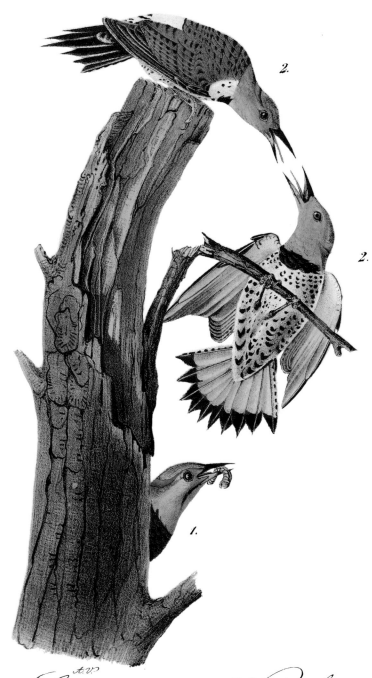

Golden-winged Woodpecker

1. Male. 2. Females.

Drawn from Nature by J.J.Audubon.F.R.S.F.L.S.

Lith.d Printed & Col.d by J.T.Bowen Phil.

Pl. 278. Carolina Parrot or Parrakeet

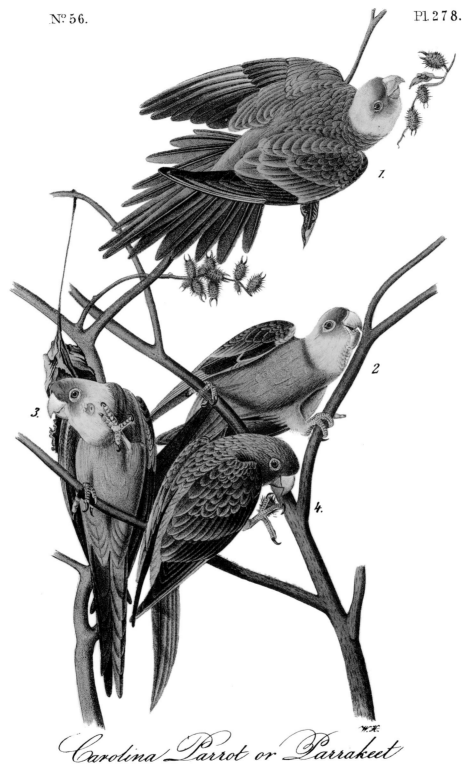

Carolina Parrot or Parrakeet

1. 2. Males . 3. Female. 4. Young.
Cockle bur.

Drawn from Nature by J.J.Audubon.F.R.S.F.L.S.

Lith⁴ Printed & Col⁴ by J.T.Bowen, Phil.

Pl. 279. Band-tailed Dove or Pigeon

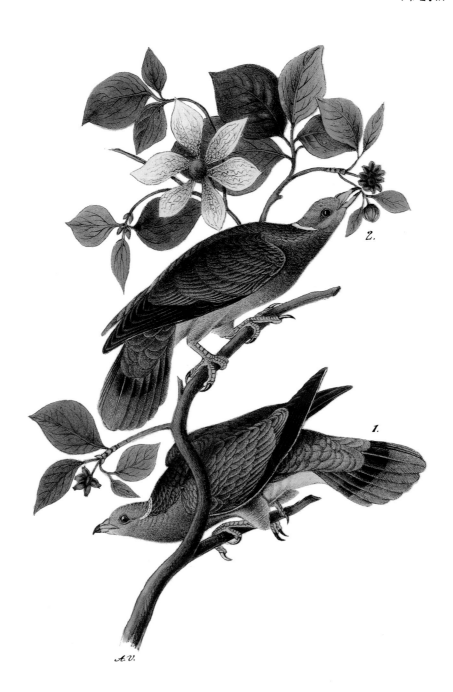

A.V.

Band-tailed Dove or Pigeon.

1. Male. 2. Female.

Cornus nuttalli

Drawn from Nature by J.J.Audubon.F.R.S.F.L.S.

Lithᵈ Printed & Colᵈ by J.T.Bowen Phil.

Pl. 280. White-headed Dove or Pigeon

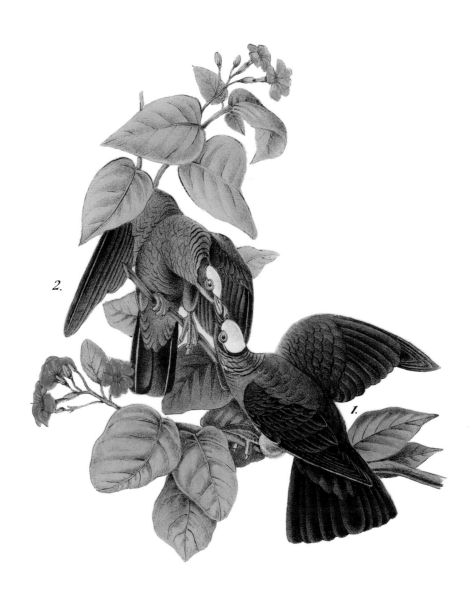

A.V.

White-headed Dove, or Pigeon

1. Male. 2. Female.

Cordia sebestina.

Drawn from Nature by J.J. Audubon. F.R.S.F.L.S.

Lithd Printed & Cold by J. T. Bowen. Phil.

Pl. 286. Carolina Turtle Dove

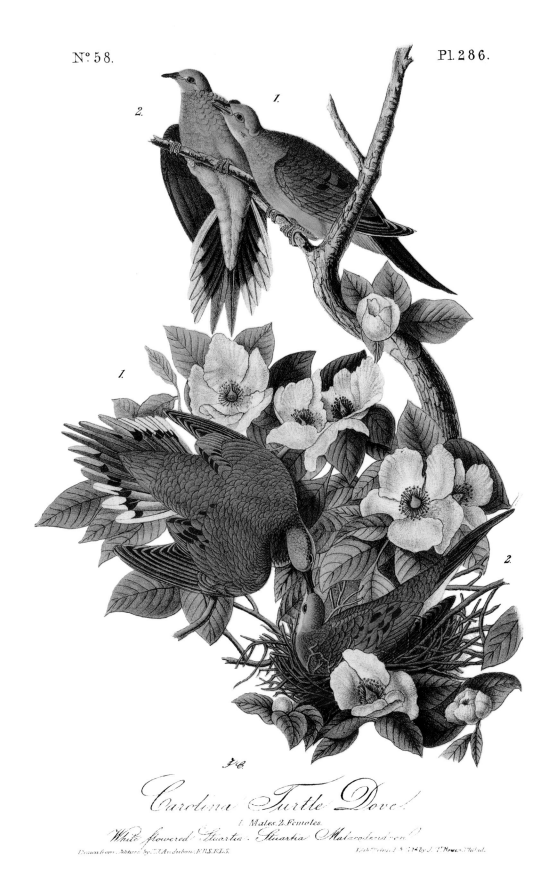

Carolina Turtle Dove.

1. Males. 2. Females.

White flowered Stuartia. Stuartia Malacodendron.

Drawn from Nature by J.J. Audubon, F.R.S. F.L.S.

Lith Printed & Cold by J. T. Bowen, Philad.

Pl. 287. Wild Turkey

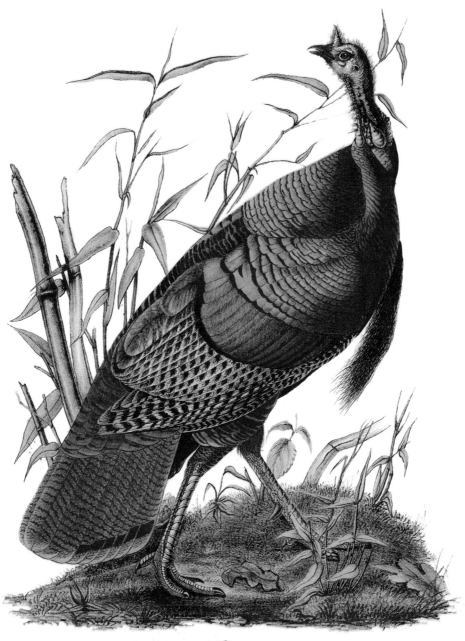

J.C.

Wild Turkey

Male.

Drawn from Nature by J.J.Audubon. F.R.S.F.L.S. Lith.d Printed & Col.d by J. T. Bowen. Phil.

Pl. 288. Wild Turkey

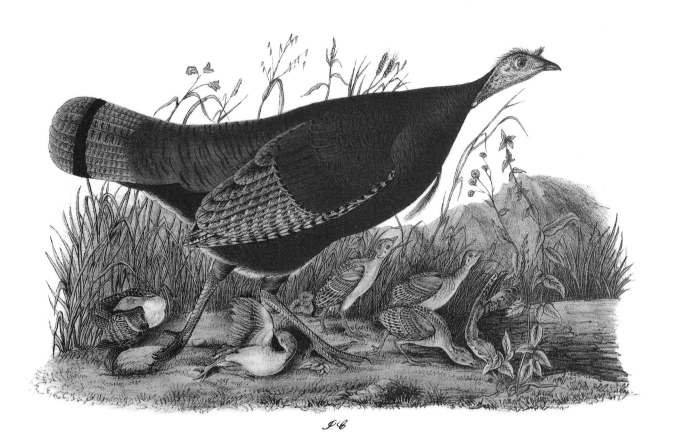

Wild Turkey. Female & Young.

Drawn from Nature by J.J.Audubon.F.R.S.F.L.S. Lith.d Printed & Col.d by J.T.Bowen.Phil.

Pl. 291. Plumed Partridge

Plumed Partridge.
1. Male. 2. Female.

Drawn from Nature by J.J.Audubon,F.R.S.F.L.S.

Lith.ᵈPrinted & Col.ᵈBy J.T.Bowen,Phil.

Pl. 301. Rock Ptarmigan

2. 1.

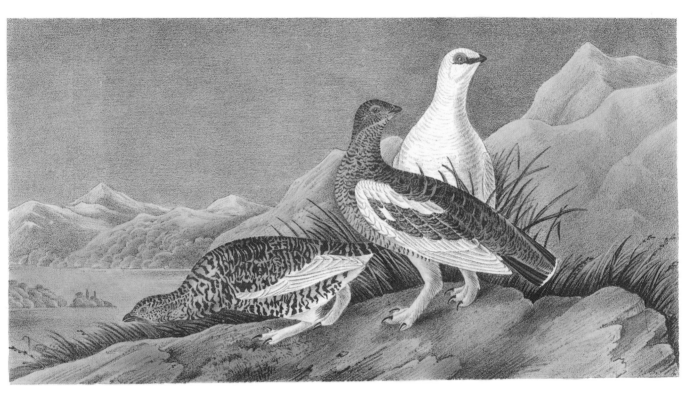

W. H.

Rock Ptarmigan
1. Male, in Winter. 2. Female, Summer Plumage, 3. Young in August.

Drawn from Nature by J.J.Audubon.F.R.S.E.L.S.

Lith? Printed & Col? by J.T.Bowen.Philad.

Pl. 303. Purple Gallinule

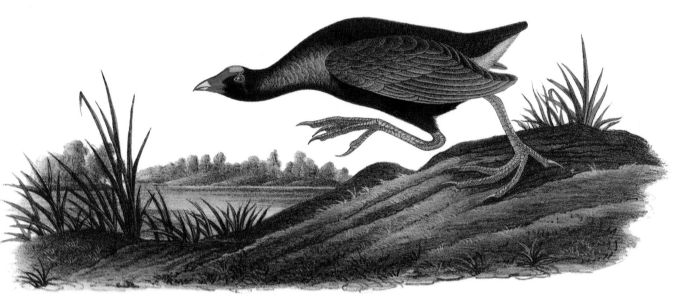

Purple Gallinule
Adult Male. Spring Plumage

Drawn from Nature by J.J. Audubon. F.R.S.F.L.S.

Lith.ª Printed & Col.ª by J.T.Bowen. Phil.

Pl. 304. Common Gallinule

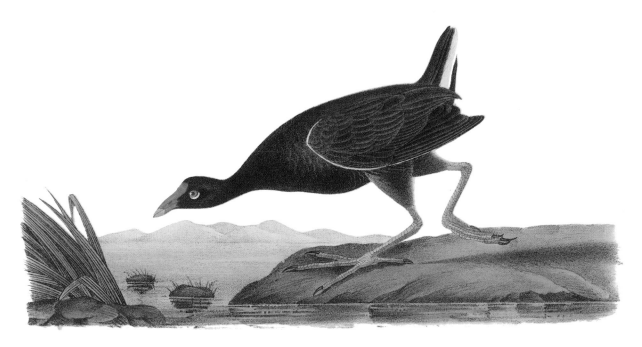

W. 76

Common Gallinule.
Adult Male.

Drawn from Nature by J.J. Audubon F.R.S.F.L.S.

Lith.d Printed & Col.d by J. T. Bowen. Philad.a

Pl. 310. Clapper Rail or Salt Water Marsh Hen

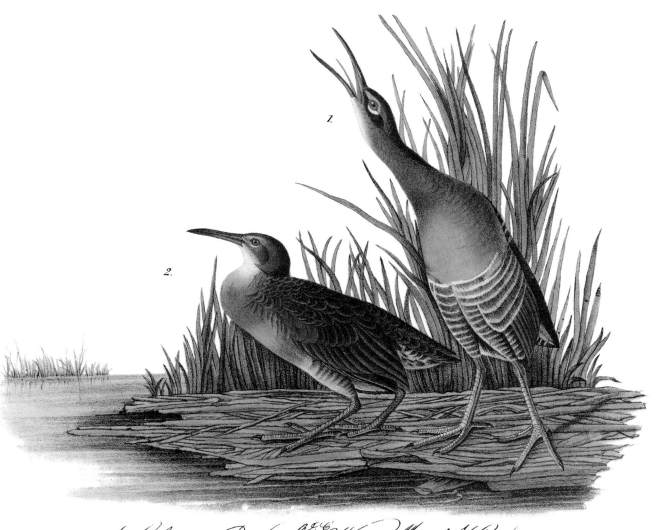

Clapper Rail or Salt Water Marsh Hen.

1. Male. 2. Female.

Drawn from Nature by J.J. Audubon F.R.S.F.L.S.

Lithᵈ Printed & Colᵈ by J.T.Bowen Phil.

Pl. 313. Whooping Crane

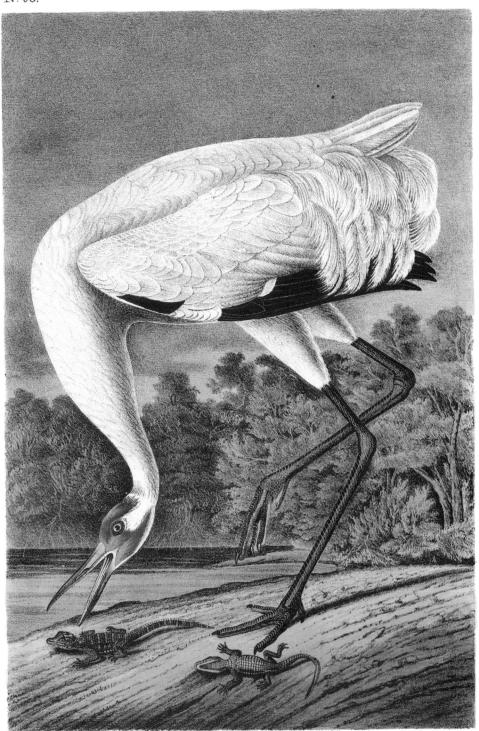

J.C.
Whooping Crane.
Male, adult

Drawn from Nature by J.J. Audubon, F.R.S.F.L.S. Lith.d Printed & Col.d by J. T. Bowen, Phil.

Pl. 314. Whooping Crane

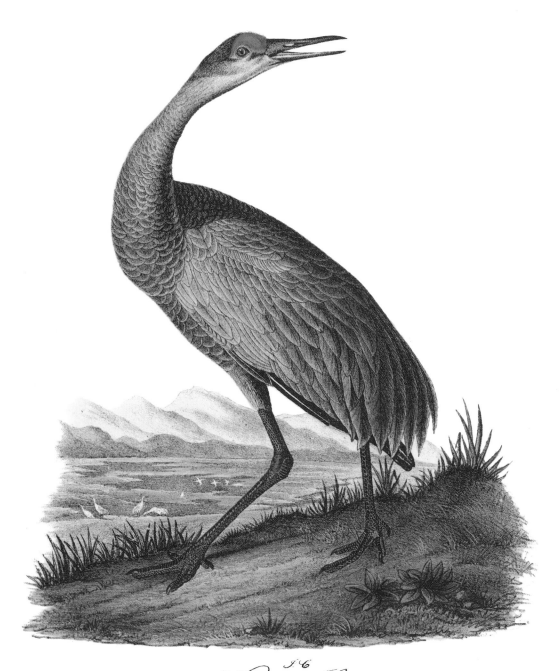

Whooping Crane
Young.

Drawn from Nature by J.J.Audubon.F.R.S.F.L.S.

Lith.d Printed & Col.d by J. T. Bowen. Phil.

Pl. 321. Piping Plover

Pl. 321.

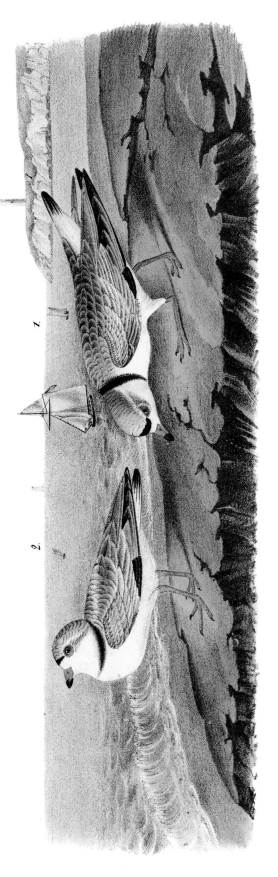

Piping Plover.
1. Male. 2. Female.

Drawn from Nature by J.J.Audubon. F.R.S.F.L.S

Lith⁴. Printed & Col⁴. by J.T.Bowen. Phil.

Pl. 323. Turnstone

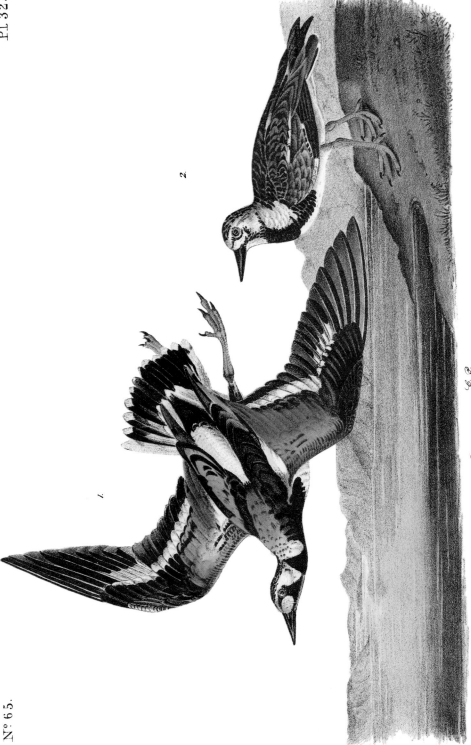

Turnstone. 1. Summer Plumage. 2. Winter.

Drawn from Nature by J.J.Audubon.F.R.S.F.L.S

Lith. Printed & Col.d by J.T.Bowen. Phil.

Pl. 333. Curlew Sandpiper

Pl. 333.

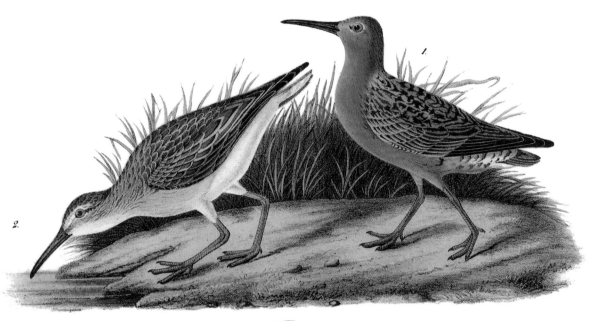

Curlew Sandpiper.
1 Adult Male. 2. Young.

Drawn from Nature by J.J. Audubon. F.R.S. F.L.S.

Lith.d Printed & Col.d by J. T. Bowen, Phil.

Pl. 344. Yellow Shanks Snipe

Pl. 344.

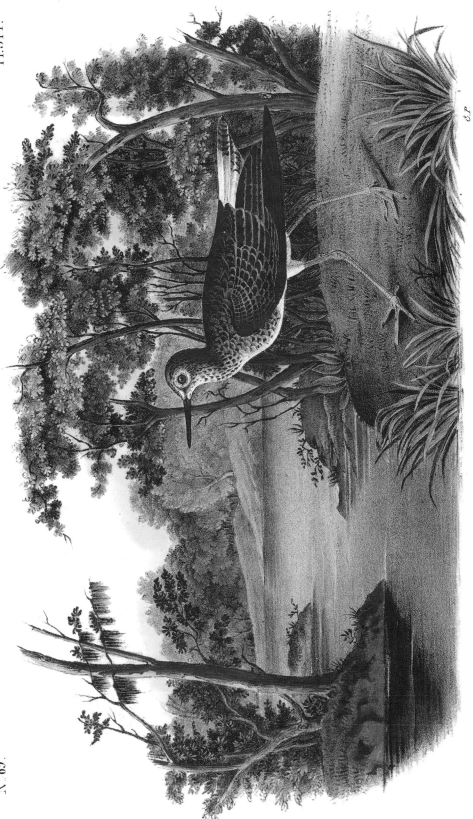

Yellow Shanks Snipe.
Male. Summer Plumage.
VIEW IN SOUTH CAROLINA.

Drawn from Nature by J. J. Audubon F. R. S. F. L. S.

Lith.d Printed & Col.d by J. T. Bowen, Phila.

Pl. 346. Greenshank

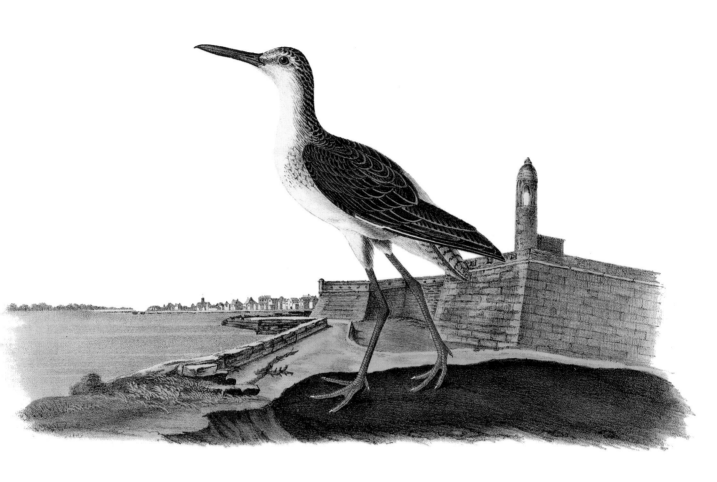

Greenshank.
Male.
VIEW OF SᵗAUGUSTINE & SPANISH FORT EAST FLORIDA.

Drawn from Nature by J.J. Audubon, F R S F L S.

Lithᵈ Printed & Colᵈ by J.T. Bowen, Phila.

Pl. 350. Wilson's Snipe Common Snipe

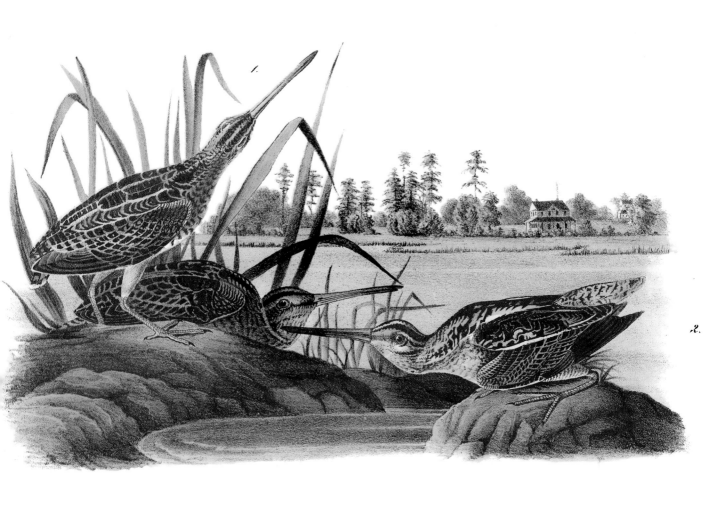

Wilson's Snipe – Common Snipe.
1, Male, 2 & 3 Females.
PLANTATION NEAR CHARLESTON, S.C.

Drawn From Nature by J. J. Audubon, F.R.S.F.L.S.

Lith'd Printed & Col'd by J. T. Bowen, Phila.

Pl. 354. Black-necked Stilt

Pl.354.

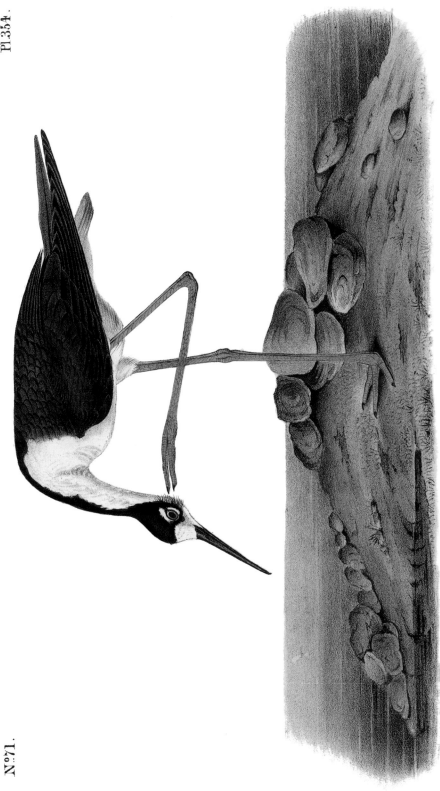

Black-Necked Stilt.

Male.

Drawn from Nature by J. J. Audubon. F.R.S. F.L.S

Lith.ª Printed & Col.ª by J. T. Bowen. Phila.

Pl. 355. Long-billed Curlew

Pl. 355.

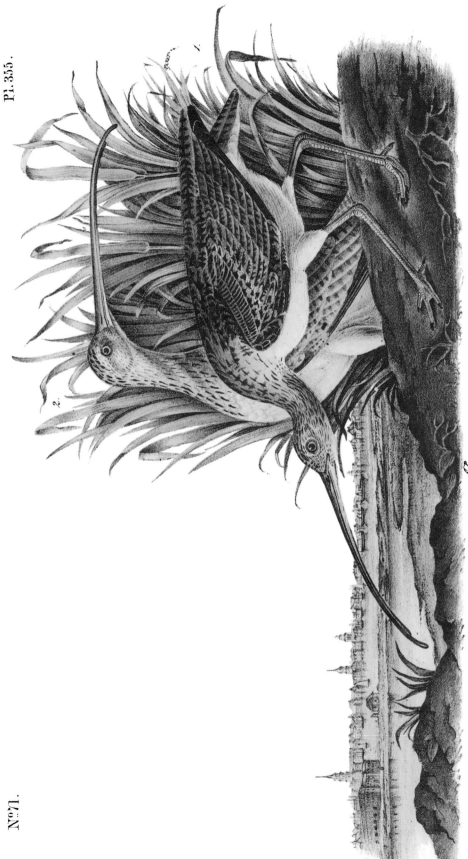

Long-billed Curlew.
1. Male. 2. Female.
CITY OF CHARLESTON.

Drawn from Nature by J. J. Audubon F.R.S. F.L.S.

Lith.d Printed & Cold by J. T. Bowen, Phila.

Pl. 358. Glossy Ibis

Pl. 358.

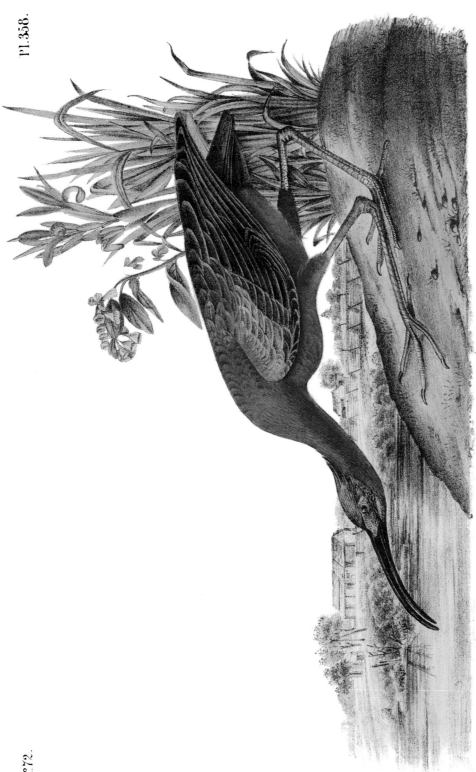

Glossy Ibis
Adult Male

Drawn from Nature by J.J. Audubon F.R.S. F.L.S.

Lith.d Printed & Col.d by J. T. Bowen, Phila.

Pl. 359. Scarlet Ibis

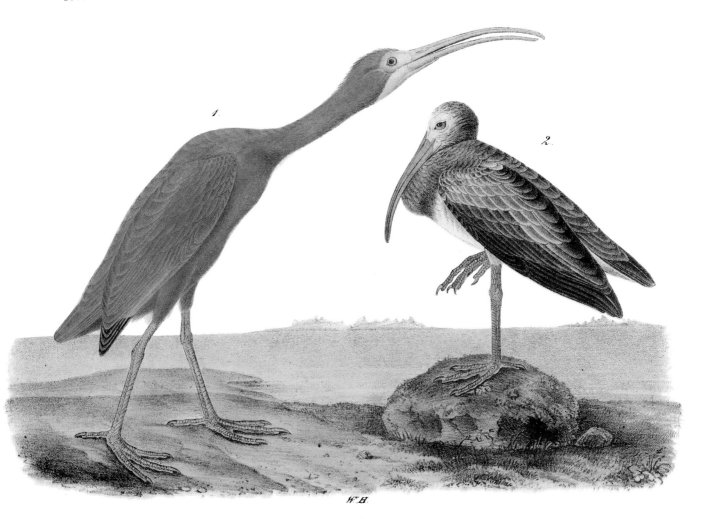

Scarlet Ibis.

1. Adult male 2. Young second Autumn.

Drawn from Nature by J. J. Audubon F. R. S. F. L. S

Lithd Printed & Cold by J. T. Bowen, Phila

Pl. 360. White Ibis

1.

2.

WH.

White Ibis.

1, Adult, 2, Young in Autumn.

Drawn from Nature by J.J.Audubon, F.R.S.F.L.S.

Lith.d Printed & Col.d by J.T. Bowen, Phila.

Pl. 361. Wood Ibis

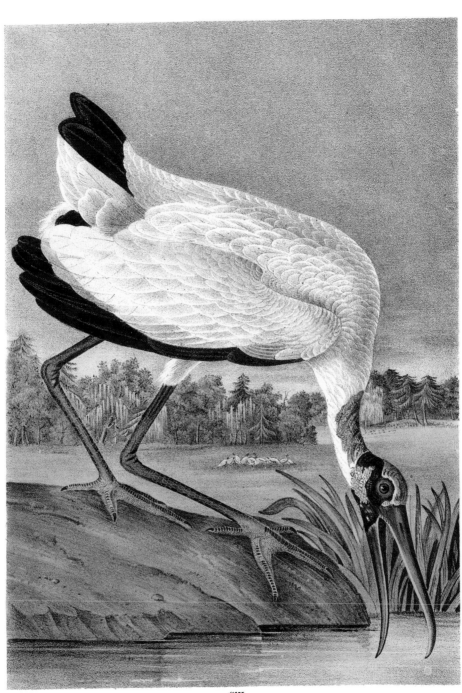

Wood Ibis.

Male

Drawn from Nature by J. J. Audubon F.R.S. F.L.S.

Lithd. Printed & Cold. by J.T. Bowen, Philadª.

Pl. 362. Roseate Spoonbill

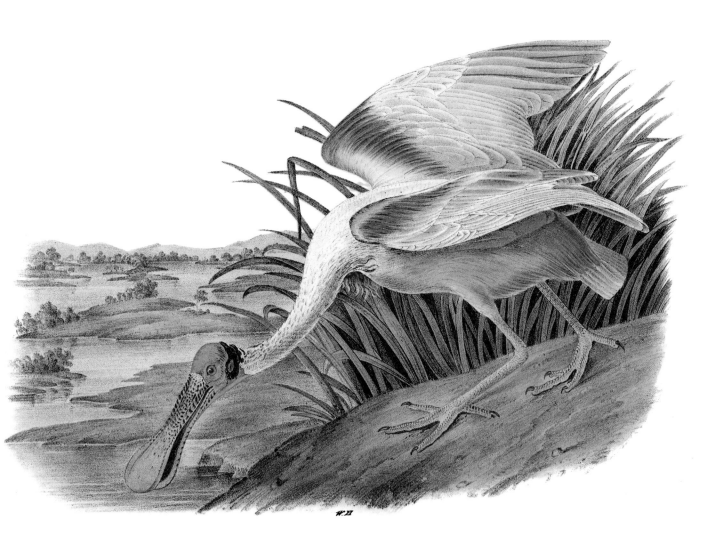

Roseate Spoonbill.

Male.

Drawn from Nature by J.J.Audubon, F.R.S.F.L.S.

Lith⁴. Printed & Col⁴ by J.T.Bowen, Philad⁴.

Pl. 363. Black-Crowned Heron or Qua Bird

Pl. 363.

Black-Crowned Night Heron, or Qua-Bird.
1. Adult. 2. Young.

Drawn from Nature by J. J. Audubon, F.R.S. F.L.S.

Lith. Printed & Col.d by J.T. Bowen. Phila.

Pl. 364. Yellow Crowned Night Heron

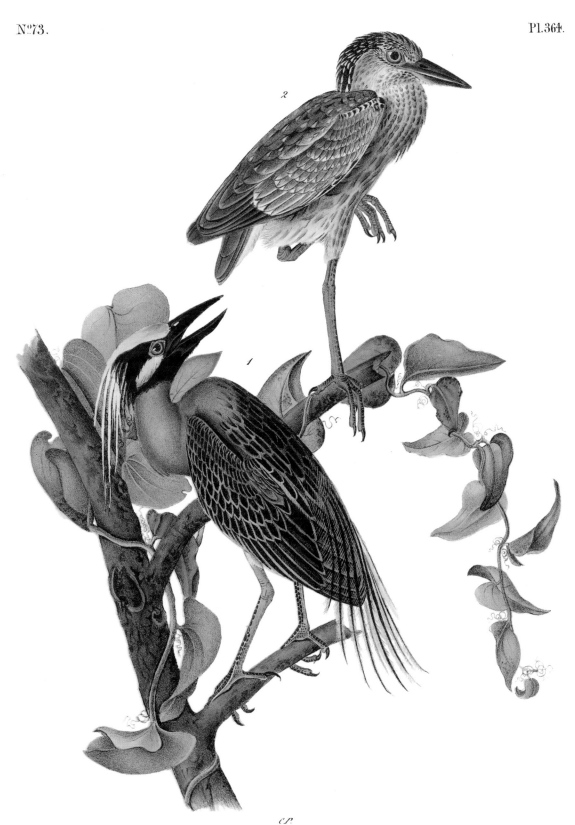

Yellow Crowned Night Heron.

Pl. 367. Green Heron

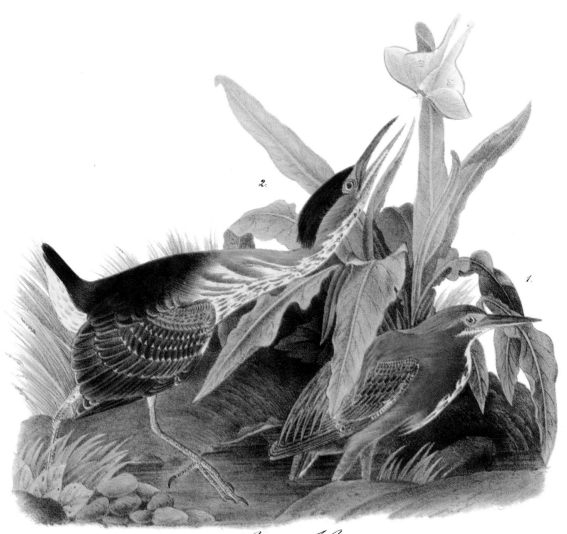

Green Heron
1. Adult Male. 2. Young in Septr.

Drawn from Nature by J.J. Audubon F.R.S.F.L.S. Lith. Printed & Colᵈ by J.T. Bowen, Phila.

Pl. 368. Great White Heron

Pl. 366.

Great White Heron.

Male adult, Spring Plumage.

Drawn from Nature by J.J.Audubon, F.R.S.F.L.S.

Lith Printed & Col.d by J.T.Bowen, Philad.a

Pl. 369. Great Blue Heron

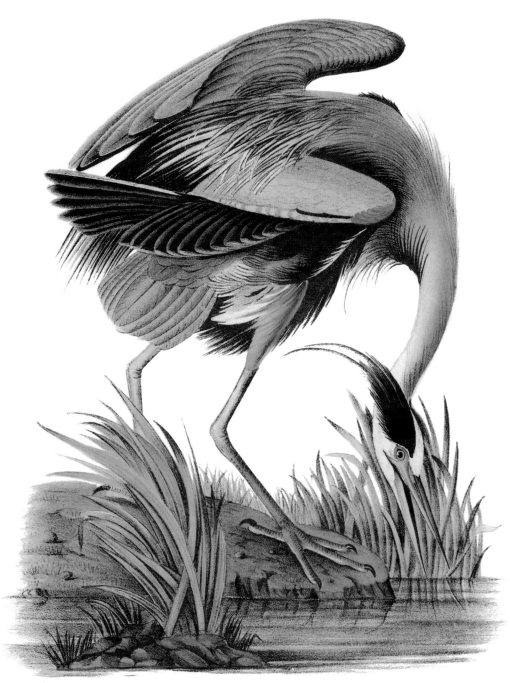

Great blue Heron.

Male

Drawn from Nature by J.J.Audubon,F.R.S.F.L.S. Lith Printed & Col.d by J.T.Bowen, Phila.

Pl. 370. Great American White Egret

Pl.370.

Great American White Egret.

1. Male, Spring Plumage. 2. Horned Agama Tapayaxin of Hernandes.

Drawn from Nature by J.J. Audubon. F.R.S. F.L.S

Lith Printed & Col.d by J.T. Bowen, Phila.

Pl. 371. Reddish Egret

Pl. 371.

Nº 75.

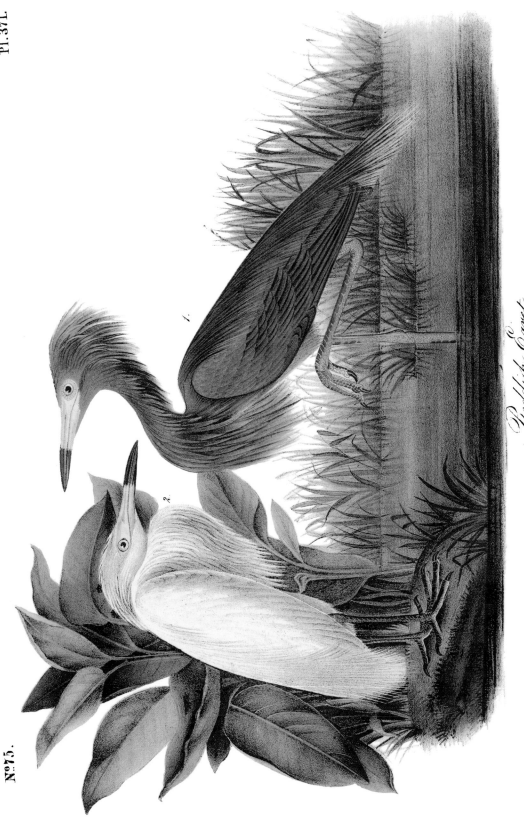

Reddish Egret.

1. Adult, Full Spring Plumage. 2. Young in full Spring Plumage two Years old.

Drawn from Nature by J. J. Audubon, F.R.S.F.L.S.

Lith. Printed & Col.ᵈ by J. T. Bowen, Phila.

Pl. 372. Blue Heron

Pl. 372.

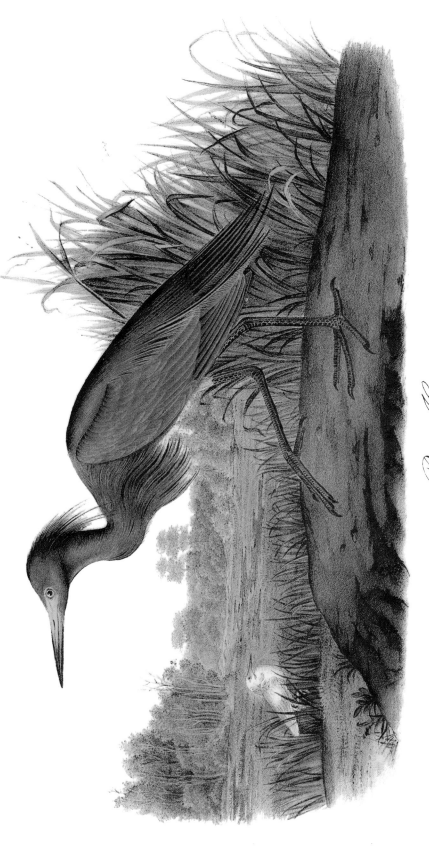

Blue Heron.

1. Male adult Spring Plumage 2. Young second Year.

Drawn from Nature by J. J. Audubon F.R.S.FL.S.

Lith⁴ Printed & Col⁴ by J.T.Bowen, Philad.

Pl. 373. Louisiana Heron

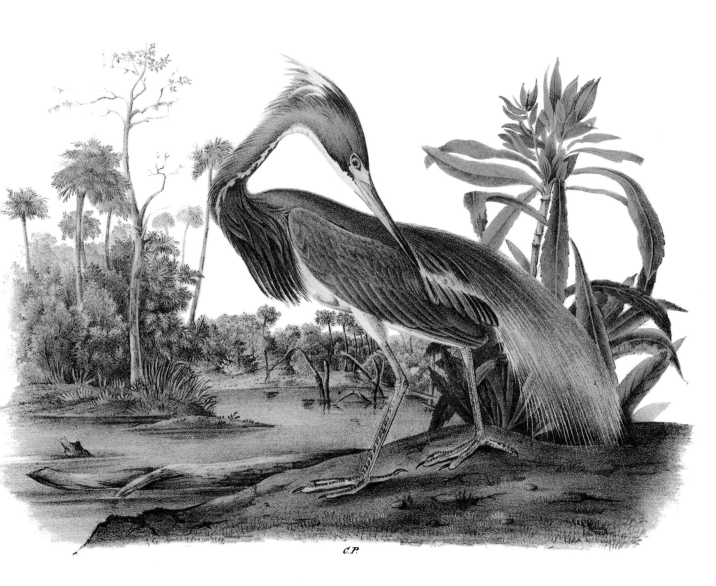

C.P.

Louisiana Heron.
Male Adult.

Drawn from Nature by J.J.Audubon,F.R.S.FLS.

Lith.Printed & Colᵈ by J.T.Bowen,Phila

Pl. 374. Snowy Heron

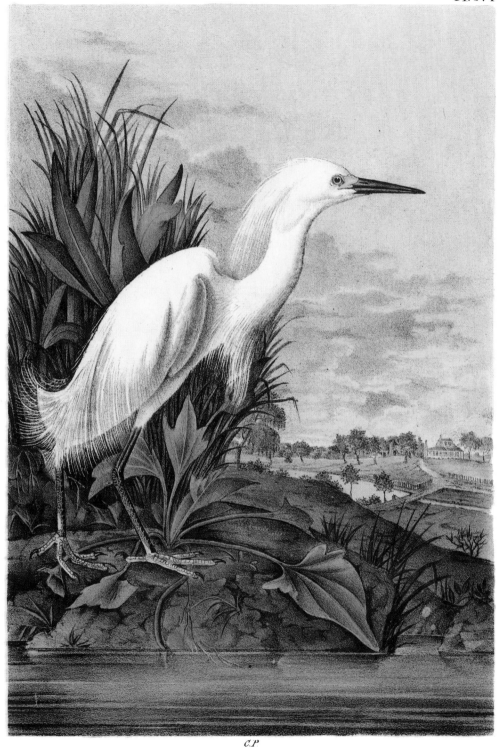

C.P.

Snowy Heron
Male

Drawn from Nature by J. J. Audubon, F.R.S.F.L.S.

Lith. Printed & Col.d by J. T. Bowen Phila.

Pl. 375. American Flamingo

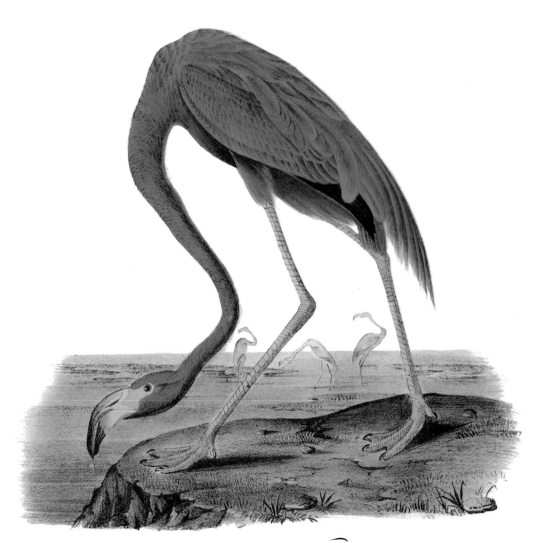

American Flamingo.
Adult Male.

Drawn from Nature by J. J. Audubon, F.R.S. F.L.S.

Lith. Printed & Colᵈ by J. T. Bowen, Phila.

Pl. 381. Snow Goose

Pl. 381.

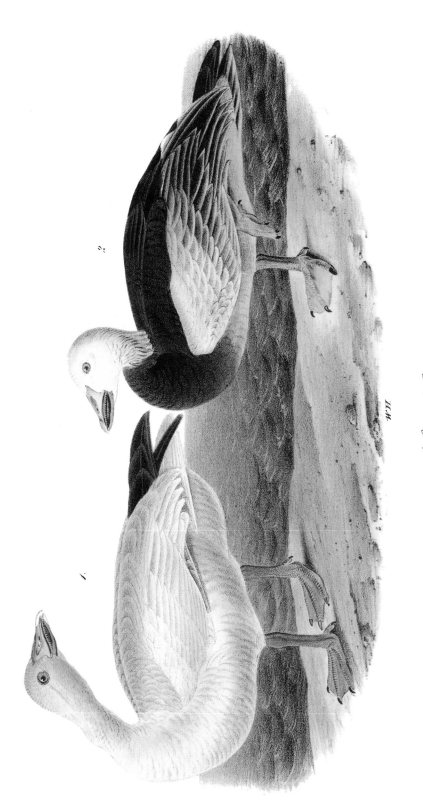

Snow Goose.

1, Adult male. 2, Young Female.

Drawn from Nature by J.J. Audubon, F.R.S.F.L.S.

Lith. Printed & Col.ᵈ by J.T. Bowen, Phila.

Pl. 391. Wood Duck Summer Duck

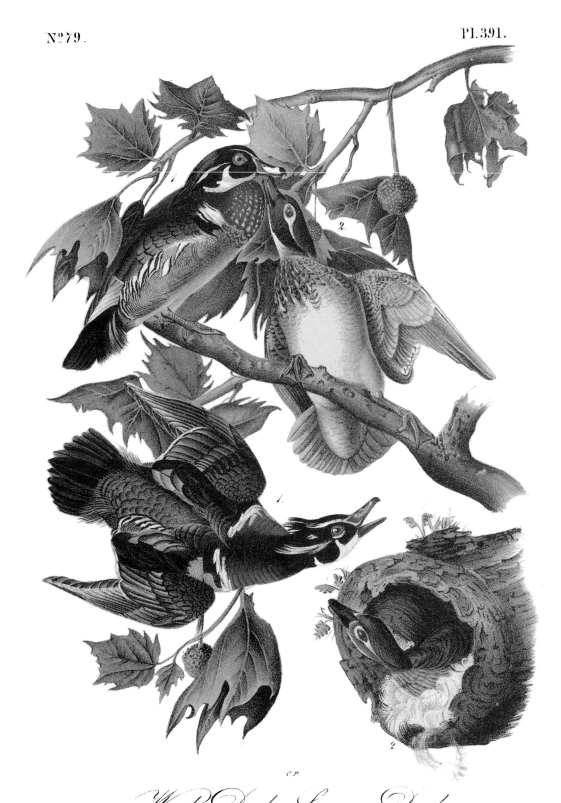

C.P.

Wood Duck Summer Duck.
1. Male. 2. Female.

Drawn from Nature by J.J.Audubon, F.R.S.F.L.S.

Lith Printed & Col.d by J.T.Bowen, Phil.

Pl. 392. American Green-winged Teal

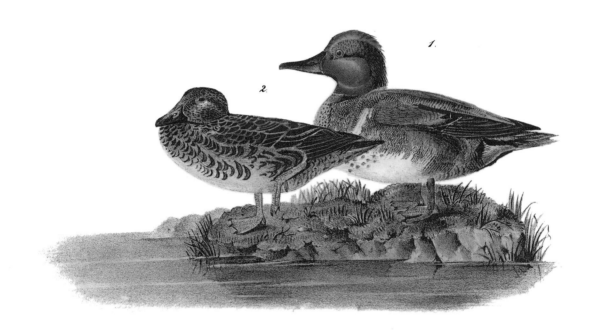

American Green-winged Teal.

1. Male 2, Female.

Drawn from Nature by J. J. Audubon, F. R. S. F. L. S.

Lith Printed & Col.ᵈ by J. T. Bowen, Phila.

Pl. 394. Shoveller Duck

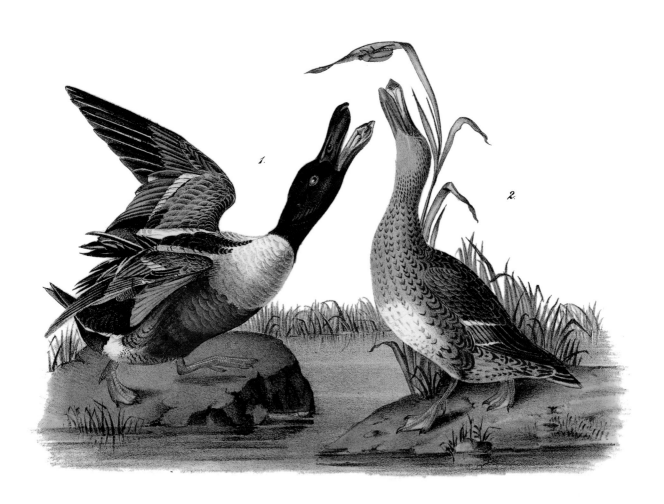

Shoveller Duck.

1, Male. 2. Female.

Drawn from Nature by J. J. Audubon, F.R.S.F.L.S.

Lith Printed & Colᵈ by J.T. Bowen, Phila.

Pl. 395. Canvass Back Duck

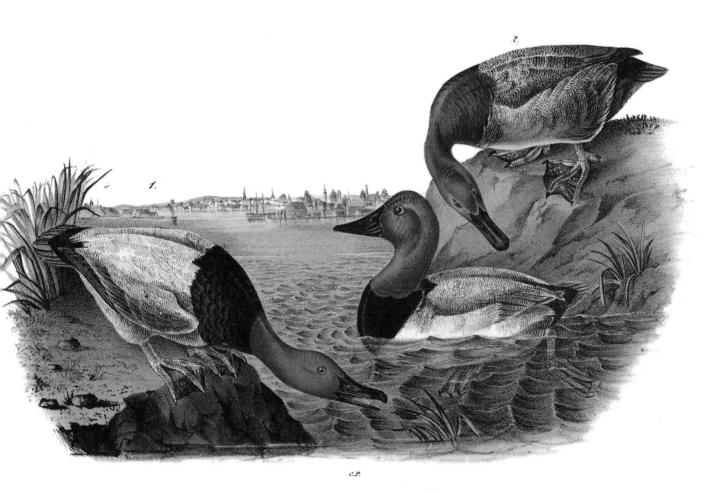

Canvass Back Duck
1, Male. 2, Female.
VIEW OF BALTIMORE, MARYLAND

Drawn from Nature by J. J. Audubon, F.R.S. P.L.S. Lith Printed & Col.d by J.T.Bowen, Phila.

Pl. 396. Red-headed Duck

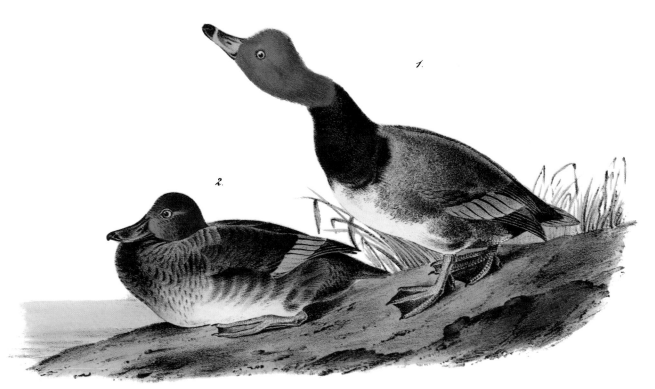

W. H.

Red headed Duck.

1. Male, 2. Female.

Drawn from Nature by J.J. Audubon, F.R.S. F.L.S

Lith. Printed & Col.ᵈ by J.T. Bowen, Phila.

Pl. 399. Ruddy Duck

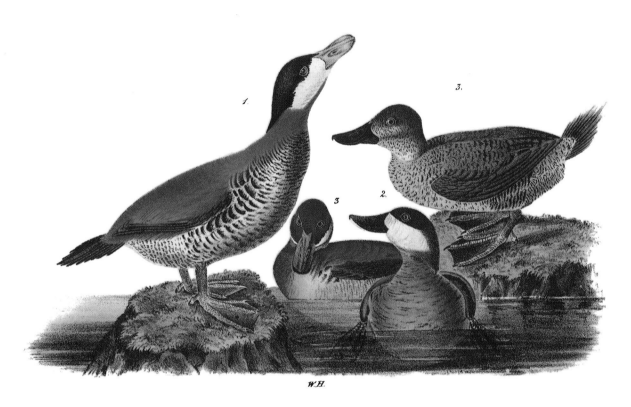

W.H.

Ruddy Duck

1, Male. 2, Female. 3, Young.

Drawn from Nature by J.J. Audubon, F.R.S.F.L.S.

Lith. Printed & Colᵈ by J.T. Bowen. Philadᵃ

Pl. 406. Golden Eye Duck

Pl. 406.

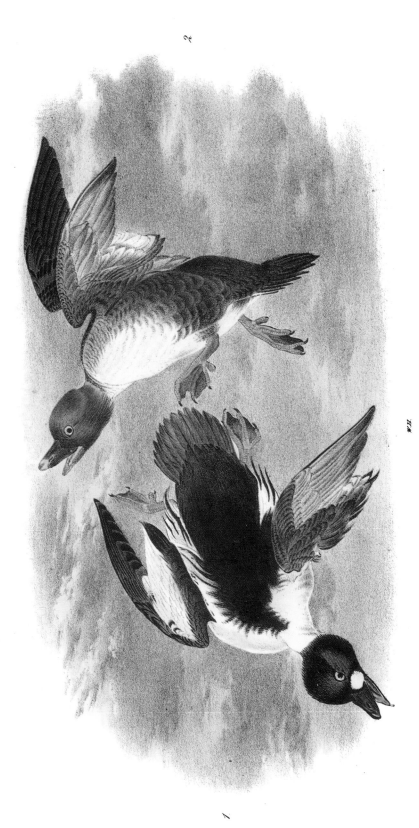

Golden Eye Duck.
1. Male 2. Female

Drawn from Nature by J. J. Audubon. F. R. S. F. L. S

Lith Printed & Col.ᵈ by J. T. Bowen, Philad.ᵃ

Pl. 407. Western Duck

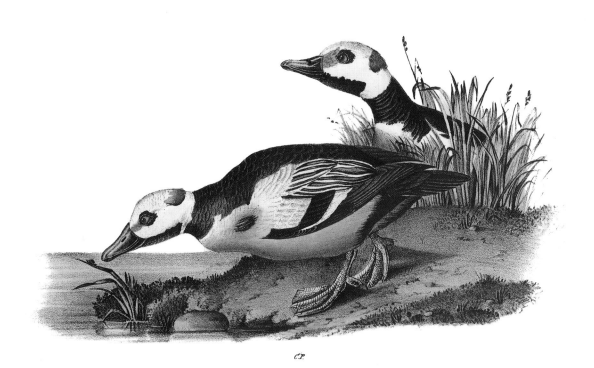

C.T.

Western Duck.

Males.

Drawn from Nature by J.J. Audubon, F.R.S.F.L.S.

Lith. Printed & Cold by J.T. Bowen, Philad<sup>

Pl. 411. Buff-breasted Merganser Goosander

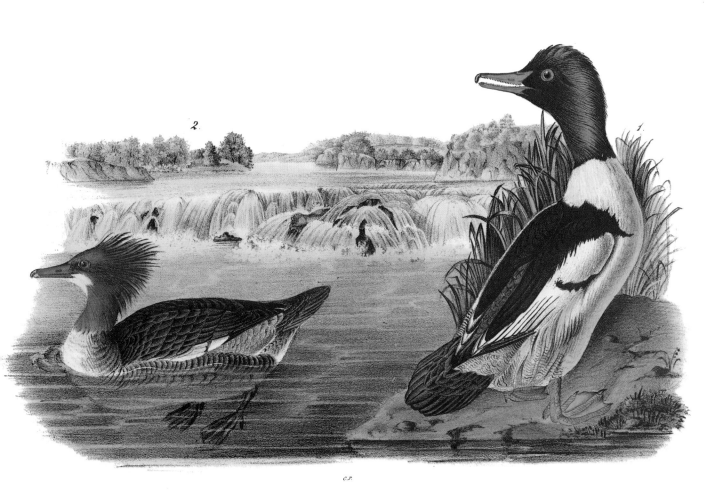

Buff breasted Merganter. Goosander.
1. Male. 2. Female.

Drawn from Nature by J.J. Audubon, F.R.S. F.L.S.

Lith. Printed & Col.d by J.T. Bowen Philad.a

Pl. 414. White Merganser, Smew, White Nun

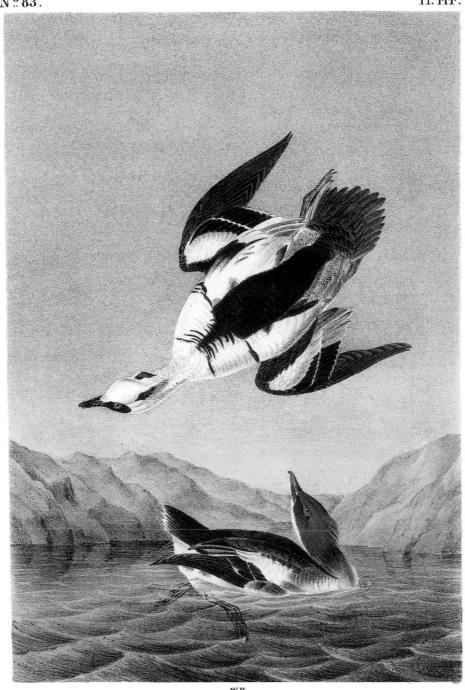

W.H.

White Merganser Smew, White Nun.
1, Male. 2, Female.

Drawn from Nature by J.J. Audubon, F.R.S. F.L.S. Lith. Printed & Col.d by J.T. Bowen, Philad.a

Pl. 415. Common Cormorant

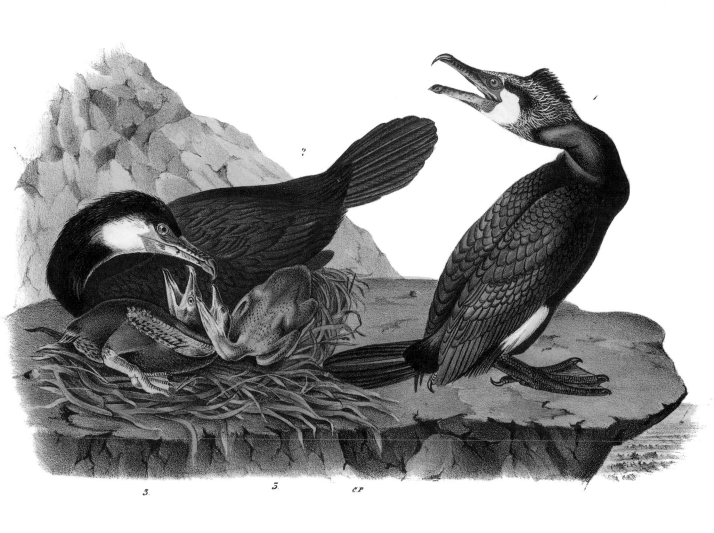

Common Cormorant.
1. Male 2. Female 3. Young.

Drawn from Nature by J.J.Audubon. F.R.S.F.L.S.
Lith. Printed & Col.d by J.T.Bowen, Philad.a

Pl. 416. Double-crested Cormorant

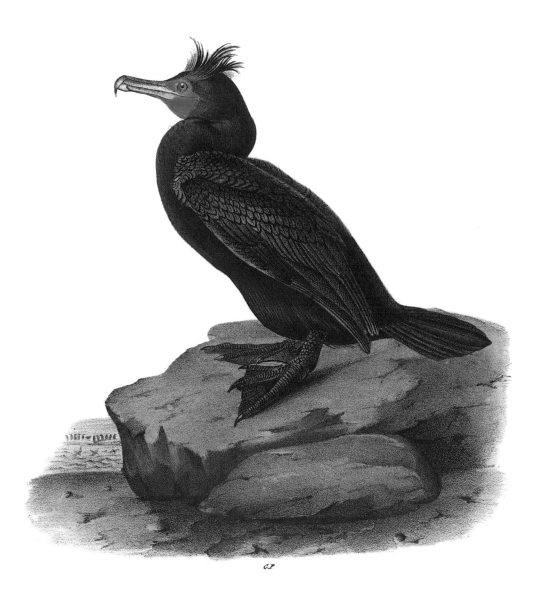

Drawn from Nature by J. J. Audubon, F.R.S.F.L.S.

Double-crested Cormorant

Male.

Lith. Printed & Col.ᵈ by J. T. Bowen, Philad.ᵃ

Pl. 419. Violet-green Cormorant

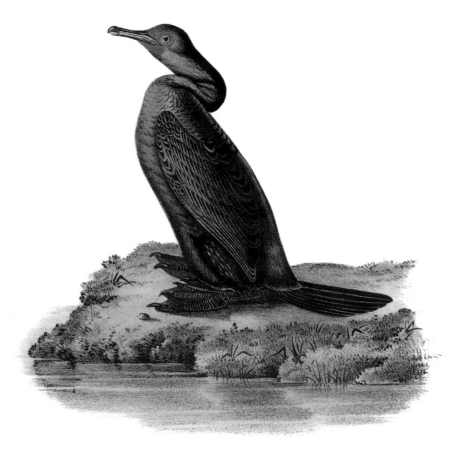

cp

Violet-green Cormorant.
Female in Winter

Drawn from Nature by J.J.Audubon,F.R.S.F.L.S. Lith. Printed & Col.ᵈ by J.T.Bowen, Philad.ᵃ

Pl. 420. American Anhinga Snake Bird

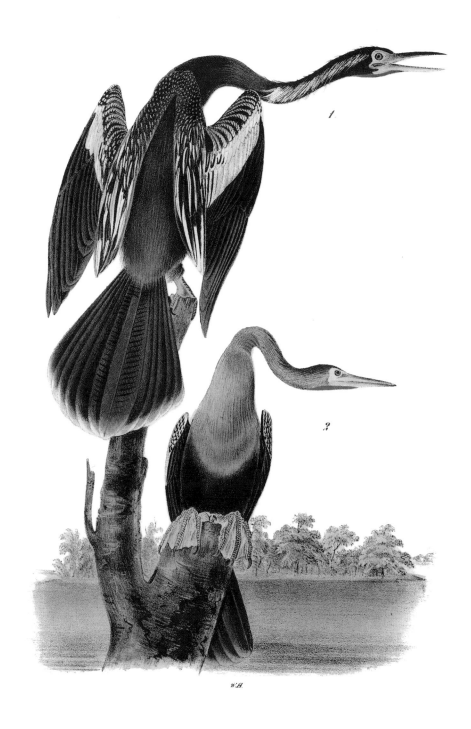

American Anhinga Snake Bird.

1. Male. 2. Female.

Drawn from Nature by J. J. Audubon, F.R.S. F.L.S.

Lith Printed & Col.d by J. T. Bowen, Phila.

Pl. 422. American White Pelican

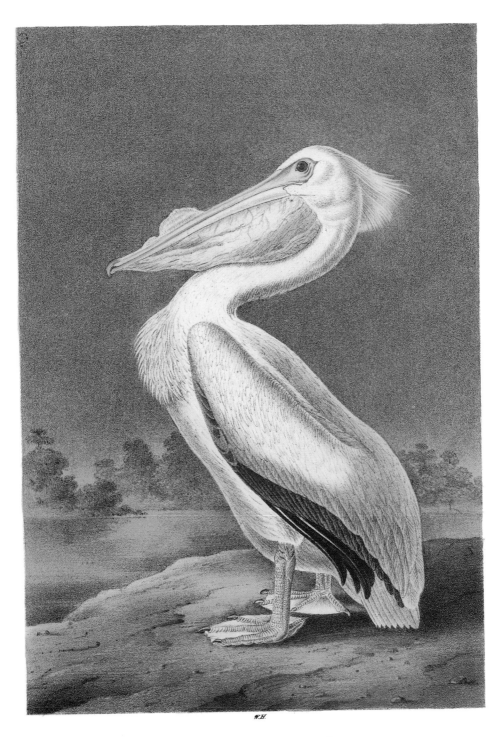

W.H.

American White Pelican.

Male.

Drawn from Nature by J.J.Audubon, F.R.S.F.L.S. Lith. Printed & Col.ᵈ by J.T.Bowen, Philad.ᵃ

Pl. 423. Brown Pelican

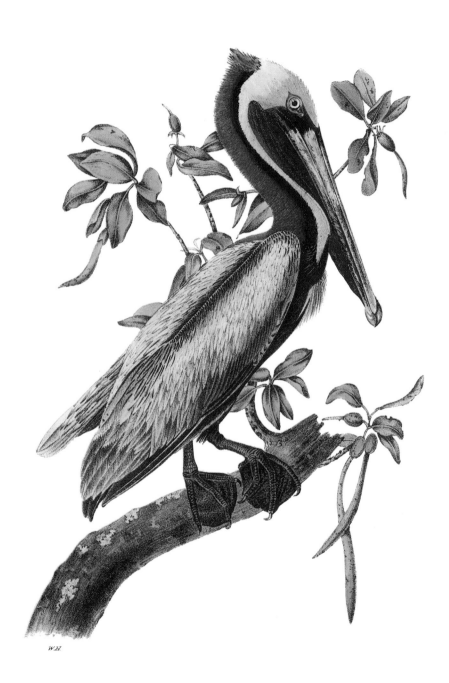

Brown Pelican.

Adult Male.

Drawn from Nature by J.J. Audubon, F.R.S. F.L.S.

Lith Printed & Col.ᵈ by J.T. Bowen, Philadelphia

Pl. 425. Common Gannet

Pl. 425.

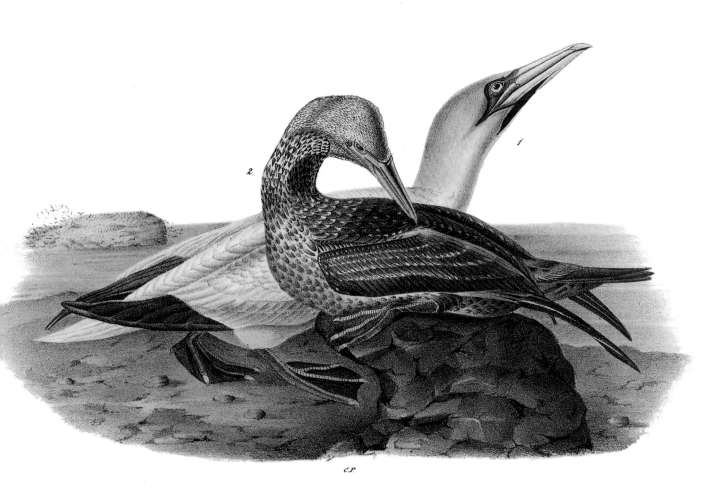

C.P.

Common Gannet.
1, Adult male. 2, Young.

Drawn from Nature by J. J. Audubon, F.R.S.F.L.S.

Lith Printed & Col.ᵈ by J. T. Bowen, Philadª

Pl. 427. Tropic Bird

Pl. 427.

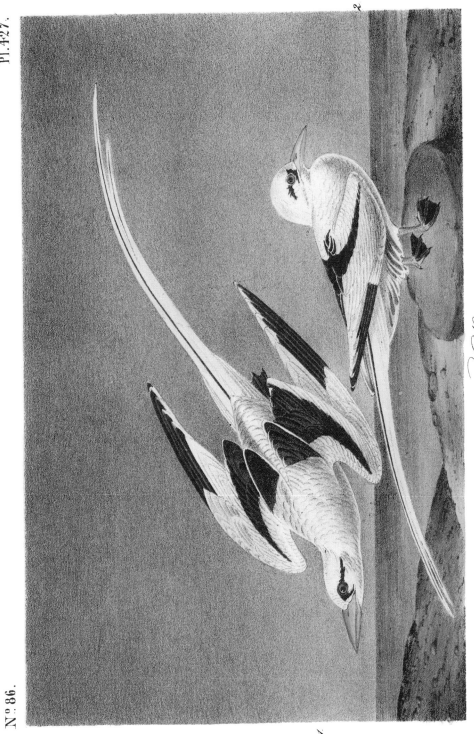

Tropic Bird.
1. Male 2. Female

Drawn From Nature by J. J. Audubon. F. R. S. FL. S

Lith. Printed & Col.ª by J. T. Bowen, Phila.

Pl. 431. Sandwich Tern

Pl. 431.

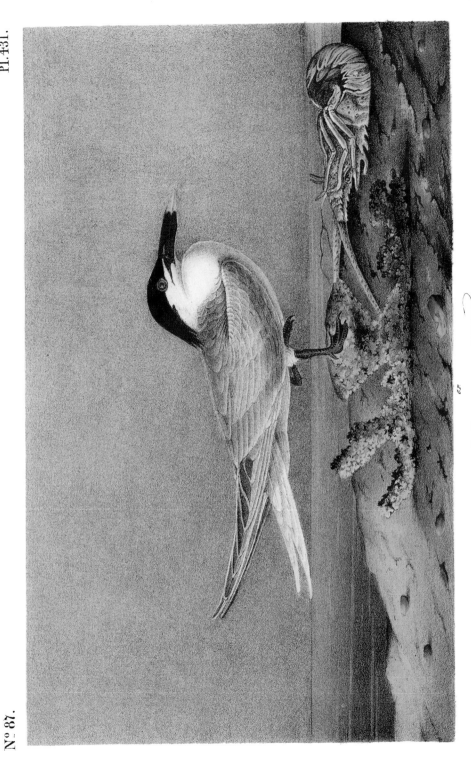

Sandwich Tern.

Adult.

Drawn from Nature by J.J. Audubon, F.R.S.F.L.S.

Lith. Printed & Col.ᵈ by J.T.Bowen, Phila.

Pl. 436. Arctic Tern

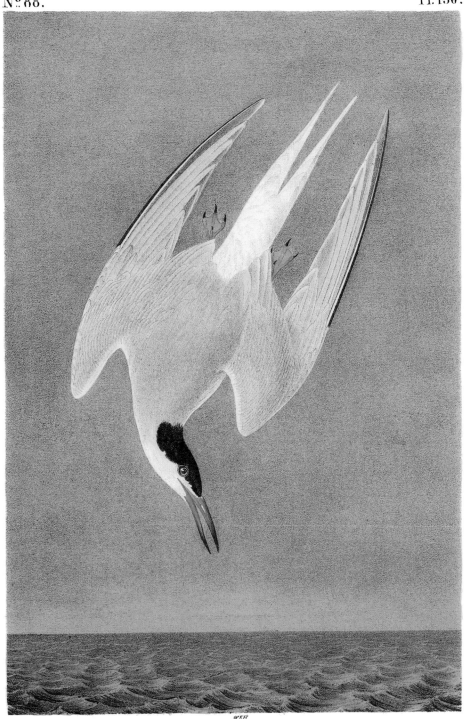

Arctic Tern.

Drawn from Nature by J. J. Audubon F. R. S. F. L. S.

Lith Printed & Col.d by J. T. Bowen, Phila.

Pl. 448. Herring or Silvery Gull

Pl. 448.

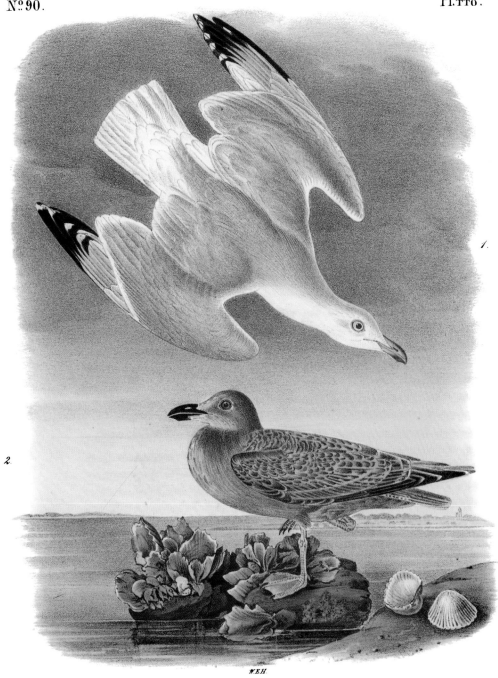

1.

2.

W.E.H.

Herring or Silvery Gull

1. Adult in Spring. 2. Young in Autumn.

Drawn from Nature by J.J.Audubon, F.R.S.F.L.S Lith. Printed & Colᵈ by J.T Bowen, Philadelphia

Pl. 454. Dusky Albatross

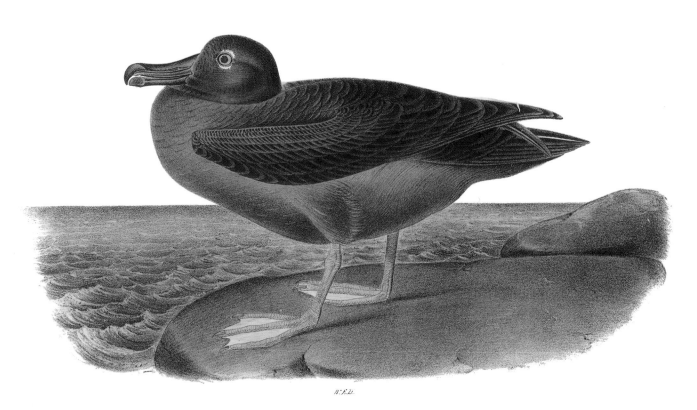

Duskye Albatross

Drawn from Nature by J. J. Audubon F.R.S. F.L.S.

Lith. Printed & Col.ᵈ by J. T. Bowen, Philad.ᵃ

Pl. 460. Wilson's Petrel Mother Carey's chicken

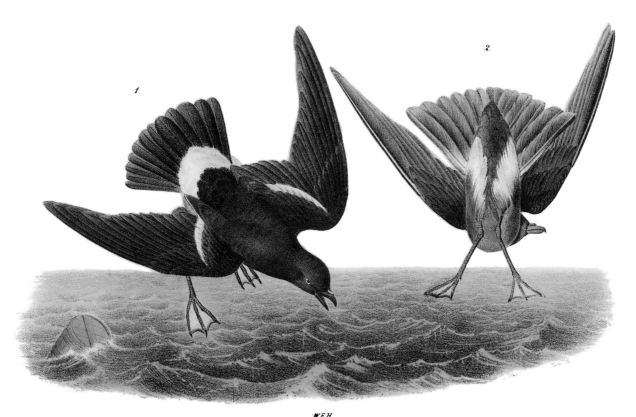

WEH

Wilson's Petrel_Mother Carey's chicken.

1. Male. 2. Female.

Drawn from Nature by J.J. Audubon, F.R.S. F.L.S.

Lith Printed & Col.ᵈ by J.T. Bowen, Philadᵃ

Pl. 464. Common or Arctic Puffin

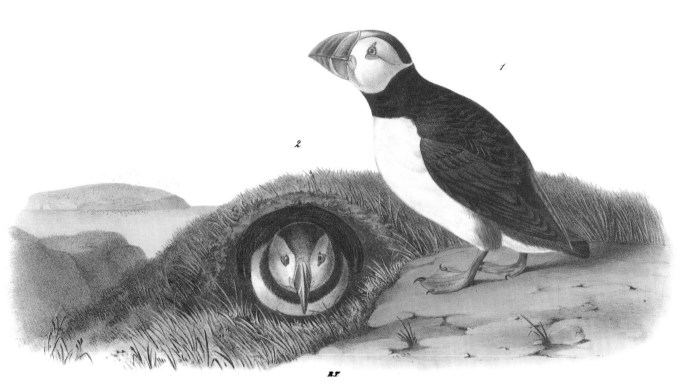

Common or Arctic Puffin.

1. Male. 2, Female

Drawn from Nature by J.J. Audubon, F.R.S.F.L.S.

Lith Printed & Cold by J. T. Bowen, Philadª

Pl. 465. Great Auk

Plate 465

Nº 94.

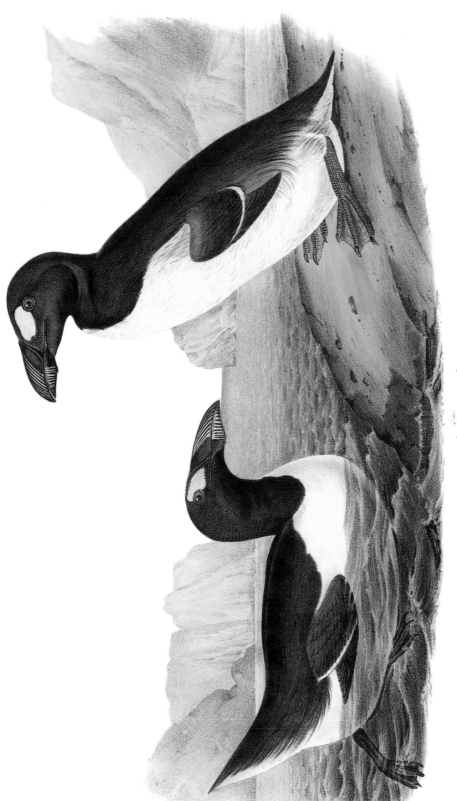

Great Auk.

Adult.

Drawn from Nature by J.J. Audubon F.R.S. F.L.S.

Lith. Printed & Cold by J.T. Bowen, Philada.

Pl. 473. Foolish Guillemot Murre

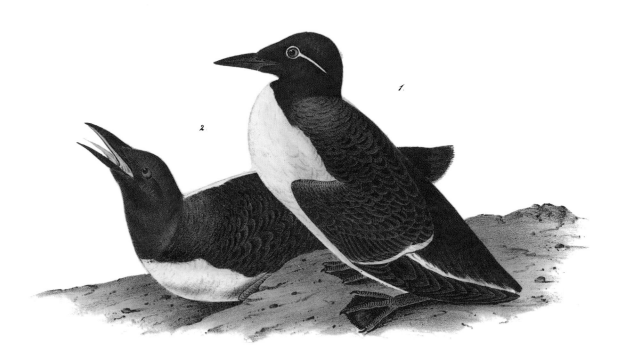

Foolish Guillemot – Murre.

1. Male. 2. Female.

Drawn from Nature by J.J. Audubon, F.R.S. F.L.S.

Lith Printed & Col.ᵈ by J.T. Bowen, Philadª.

Pl. 474. Black Guillemot

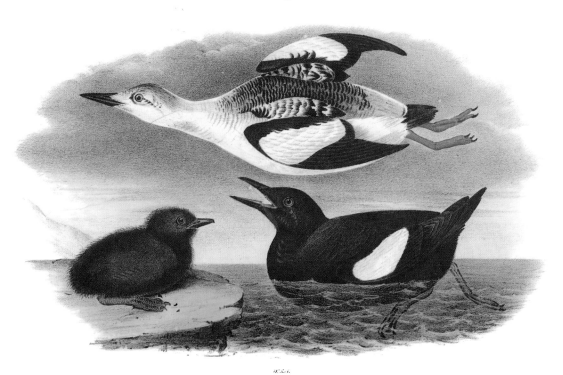

Black Guillemot.

1, Adult. — Summer Plumage. — 2, Adult in Winter. — 3, Young.

Drawn from Nature by J.J.Audubon, F.R.S.F.L.S.

Lith. Printed & Col.^d by J.T. Bowen, Philad.^a

Pl. 476. Great Northern Diver Loon

Pl. 476.

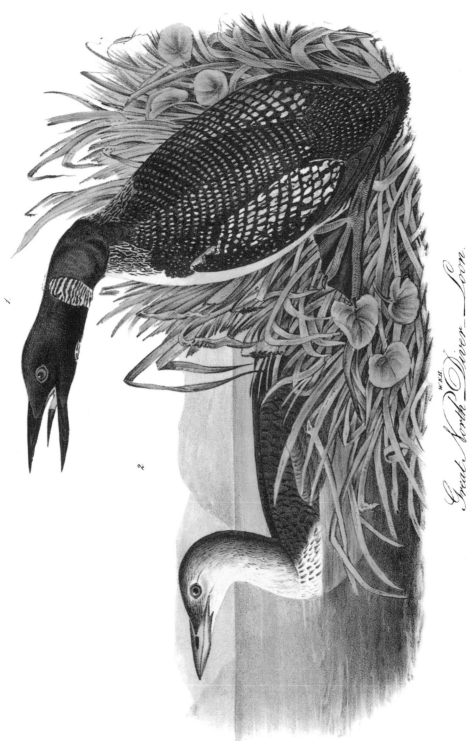

Great North Diver_ Loon.

1. Adult. 2. Young in Winter_

Pl. 478. Red-throated Diver

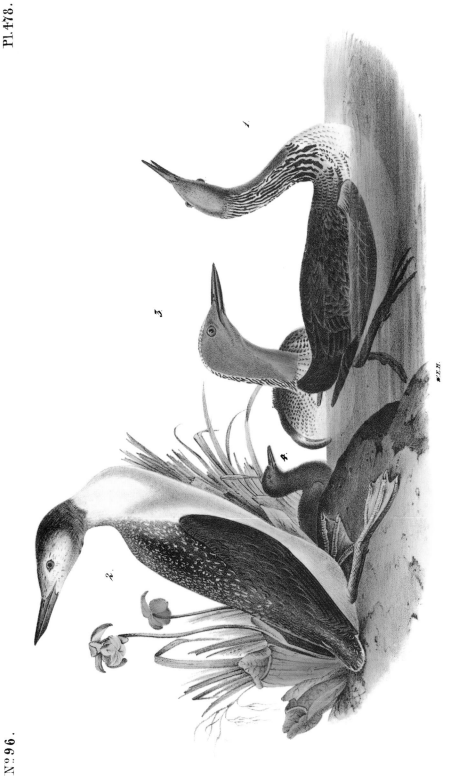

Pl.478.

Red-throated Diver.

1.Male Summer Plumage 2, do Winter 3, Female 4, Young

Drawn From Nature by J.J Audubon, F.R.S.F.L.S

Lith Printed & Col.ᵈ by J.T Bowen,Philad.ᵃ

Pl. 479. Crested Grebe

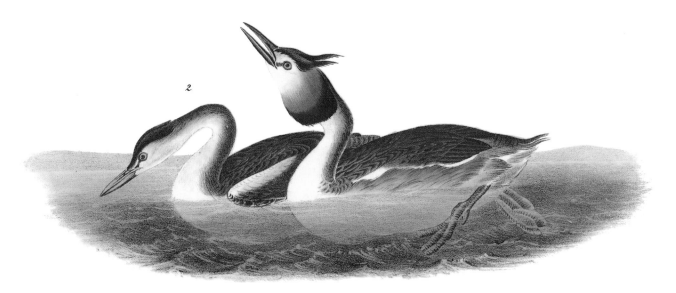

W.E.H.

Crested Grebe

1. Adult Male in Spring. 2. Young (First Winter.)

Drawn from Nature by J.J. Audubon, F.R.S. F.L.S.

Lith Printed & Col.d by J.T. Bowen, Phila.

Pl. 481. Horned Grebe

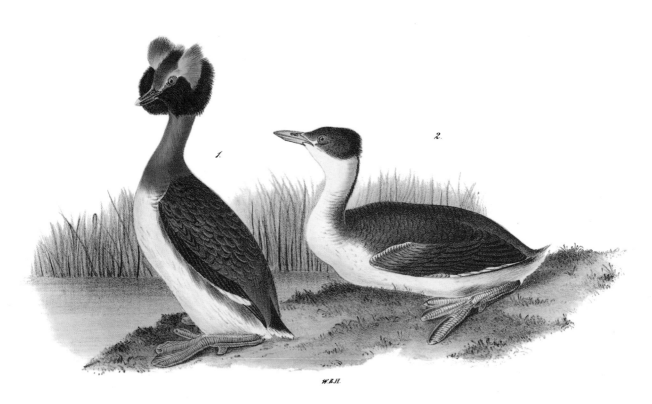

W.B.H.

Horned Grebe.

1, Adult Male. 2, Female in Winter.

Drawn from Nature by J. J. Audubon. F.R.S.F.L.S.

Lith. Printed & Col.ᵈ by J.T.Bowen, Philad.ᵃ

Pl. 490. Yellow-bellied Flycatcher

Pl. 490.

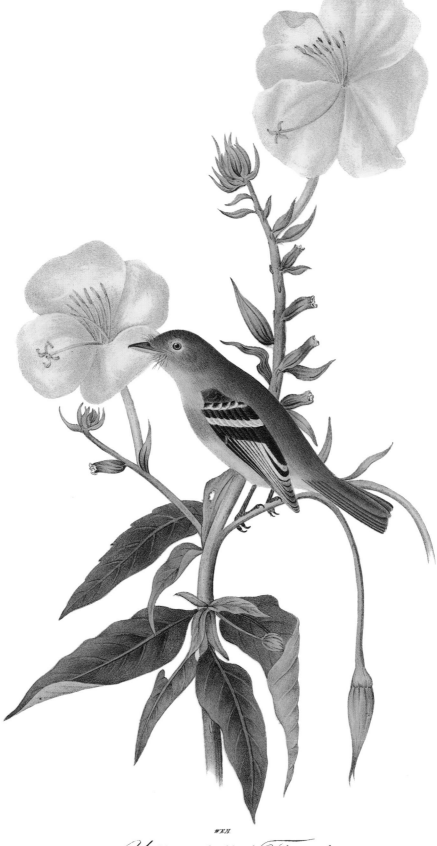

WEH

Yellow-bellied Flycatcher

Male

Pl. 494. Missouri Red-moustached Woodpecker

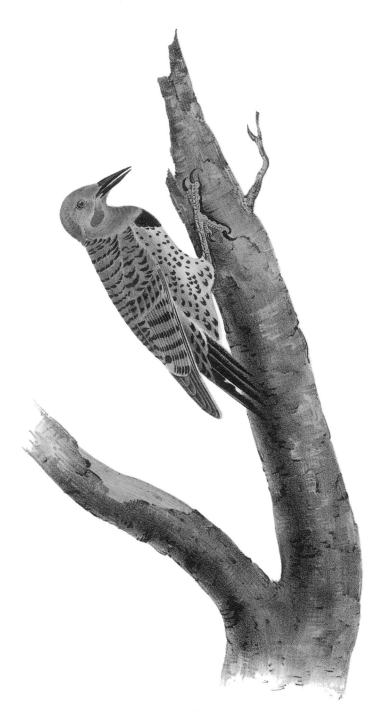

WEH.

Missouri Red-moustached Woodpecker

Male

Drawn from Nature by J. J. Audubon, F.R.S.F.L.S

Lith. Printed & Col.d by J. T. Bowen, Philad.a

Pl. 497. Western Shore Lark

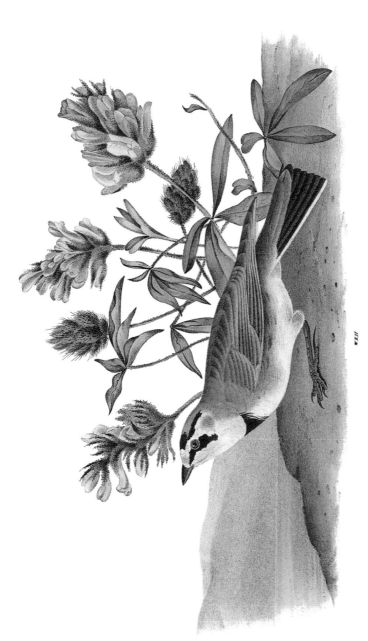

Pl. 497.

N°. 100.

Western Shore Lark

Male

Drawn from Nature by J. J. Audubon. F.R.S. F.L.S.

Lith. Printed & Col.d by J. T. Bowen, Philad.a

Pl. 498. Common Scaup Duck

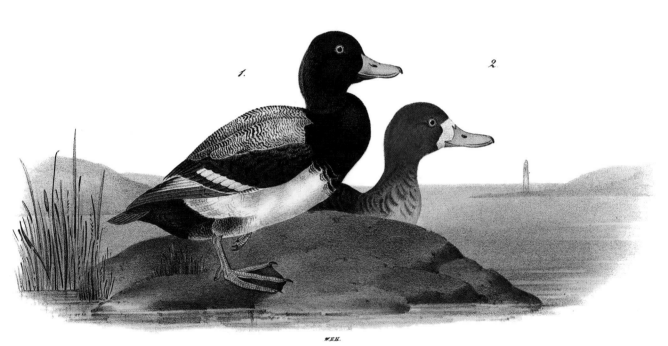

1.

2.

WEH.

Common Scaup Duck.

1, Male. 2, Female.

Drawn from Nature by J.J.Audubon, F.R.S. F.L.S.

Lith. Printed & Col.d by J.T.Bowen, Philad.a

Pl. 499. Common Troupial

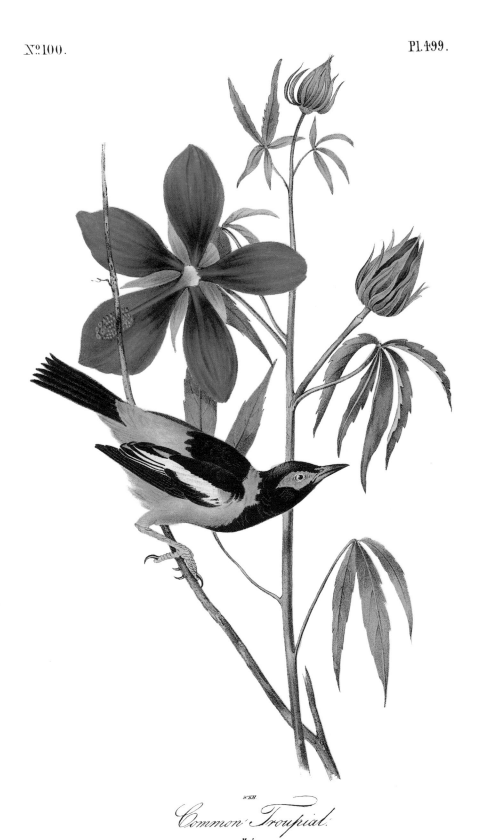

Common Troupial.

Male.

Drawn from Nature by J.J. Audubon, F.R.S.F.L.S.

Lith. Printed & Colᵈ by J.T. Bowen, Philadᵃ.